PAINTER'S QUICK REFERENCE

Flowers & Blooms

EDITORS OF NORTH LIGHT BOOKS

NORTH LIGHT BOOKS
CINCINNATI, OHIO
www.artistsnetwork.com

Distributed in Canada by Fraser Direct
100 Armstrong Avenue
Georgetown, ON, Canada L7G5S4

Distributed in the U.K. and Europe by David & Charles
Brunel House, Newton Abbot, Devon TQ12 4PU, England
Tel: (+44) 1626 323200, Fax: (+44) 1626 323319
Email: mail@davidandcharles.co.uk

Distributed in Australia by Capricorn Link
P.O. Box 704, Windsor, NSW 2756 Australia

Other fine North Light Books are available from your local bookstore, art supply store or direct from the publisher.

09 08 07 06 05 5 4 3 2 1

Library of Congress Cataloging-in-Publication Data

Painter's quick reference : flowers & blooms / editors of North Light Books.-- 1st ed.
 p. cm.
 Includes index.
 ISBN 1-58180-760-0 (hardback concealed wire-o : alk. paper) -- ISBN 1-58180-761-9 (pbk. : alk. paper)
 1. Flowers in art. 2. Painting--Technique. I. North Light Books (Firm) II. Title. Flowers.
ND1400.P3335 2005
751.45'4343--dc22
 2005004316

Editor: Holly Davis
Designer: Karla Baker and Jenna Habig
Interior Layout Artist: Jenna Habig
Production Coordinator: Kristen Heller

Metric Conversion Chart

to convert	to	multiply by
Inches	Centimeters	2.54
Centimeters	Inches	0.4
Feet	Centimeters	30.5
Centimeters	Feet	0.03
Yards	Meters	0.9
Meters	Yards	1.1
Sq. Inches	Sq. Centimeters	6.45
Sq. Centimeters	Sq. Inches	0.16
Sq. Feet	Sq. Meters	0.09
Sq. Meters	Sq. Feet	10.8
Sq. Yards	Sq. Meters	0.8
Sq. Meters	Sq. Yards	1.2
Pounds	Kilograms	0.45
Kilograms	Pounds	2.2
Ounces	Grams	28.3
Grams	Ounces	0.035

Introduction

WHEN YOU'RE IN A HURRY FOR PAINTING HELP, HERE'S THE BOOK TO COME TO FOR IDEAS, INSTRUCTIONS AND INSPIRATION.

Few subjects inspire an artist more than flowers. You need only flip through the pages of this book to see the evidence. Here you not only find painting instruction for a variety of flowers, but you can explore the painting styles and teaching approaches of a variety of artists working in a variety of mediums. Sometimes the same flower is presented two or three times—a reminder that every flower offers infinite creative possibilities.

You can use this book many ways. Leaf through the pages to jump start your creative process. Use the finished art as a reference for accurate floral depictions. Select a particular demonstration and follow it step by step. Skim the text to pick up a tip here and an insight there. Apply an artist's technique to your own composition.

Perhaps you'll be moved to explore a new medium, such as gouache, used in Erin O'Toole's calla lily, or Chinese watercolor, used in Lian Quan Zhen's trumpet creeper and tiger lily. Interested in negative painting? Try Linda Kemp's forget-me-nots or Margaret Roseman's apple blossoms. Want to improve your strokework? You'll learn plenty from Maureen McNaughton's lilacs and Donna Dewberry's rose. Increase your understanding of the uses of different brushes with Lauré Paillex's round, filbert and foliage brush demonstrations. Let Pat Weaver's poinsettia painting open your eyes to the rainbow of values you can achieve from a few tubes of watercolor.

Feeling inspired already? Well that's just the beginning. Turn the page and let yourself go.

 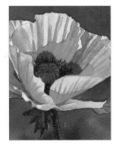 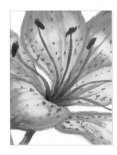 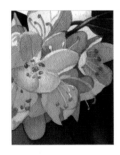

Table of Contents

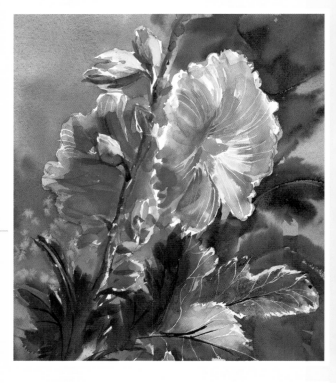

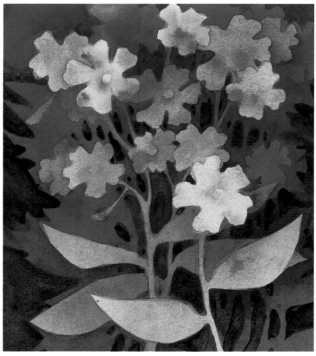

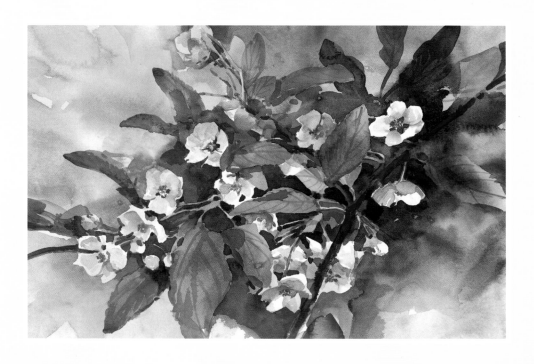

Allamanda

SHERRY NELSON

MEDIUM: *Oil*

COLORS: ***Winsor & Newton Artists' Oil Colour:*** *Ivory Black • Titanium White • Raw Sienna • Sap Green • Cadmium Yellow Pale • Cadmium Red • Alizarin Crimson • Mauve Blue Shade • Purple Madder*

BRUSHES: ***Winsor & Newton:*** *Red Sable Bright, series 710 - nos. 2, 4, 6 • Liner, series 740 - no. 0*

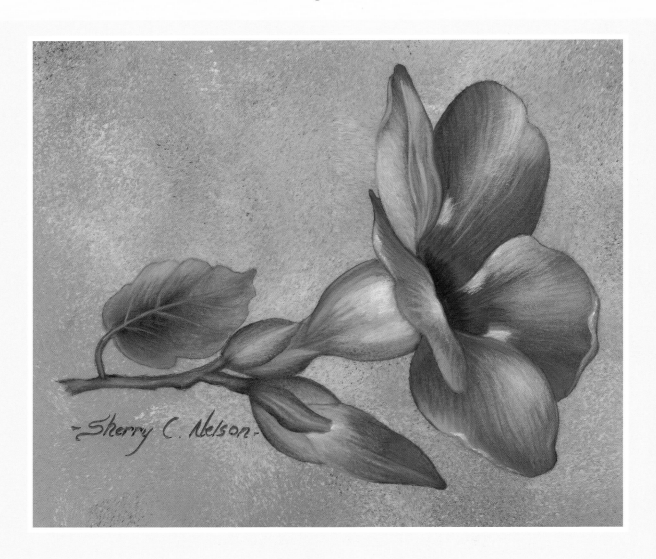

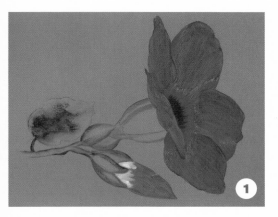

1 Base

Paint the blossom's dark areas Purple Madder, the medium areas Cadmium Red + Alizarin Crimson and the light areas Mauve Blue Shade + Raw Sienna + a bit of Titanium White. Paint the trumpet's yellow area Cadmium Yellow Pale + Raw Sienna and the purple area Mauve Blue Shade + Raw Sienna. Paint the bud's dark area Cadmium Red + Alizarin Crimson, the medium area Mauve Blue Shade + Raw Sienna + Titanium White and the light area Titanium White. Paint leaves' and calyxes' dark areas Ivory Black + Sap Green and the light areas Sap Green + Titanium White.

2 Blend

Blend on the blossom where values meet, following growth direction and using the chisel edge. Base the trumpet's green area Ivory Black + Sap Green + Titanium White. Blend on the bud where values meet, following growth direction.

3 Highlight

Highlight the blossom with Titanium White + a bit of Mauve Blue Shade + a bit of Raw Sienna. Base the remaining area of the trumpet with Titanium White. Highlight the bud with the same mix used for the blossom. Highlight the leaves and calyxes with Sap Green + Titanium White (use more white than in step 1).

4 Blend and Add Detail

Blend on the blossom where values meet. Add fine detail with a dirty brush + Titanium White, using the chisel. Blend on the trumpet where values meet. Highlight with more white if needed. Blend on the bud where values meet. Add fine detail as you did in the blossom. Blend the highlight on the leaves and calyxes. Then add vein structure with Sap Green + Titanium White. Detail fine lines on the calyxes using Ivory Black + Sap Green.

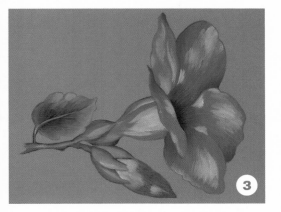

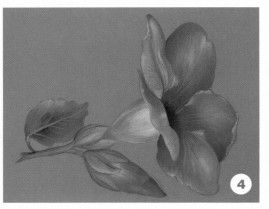

artist's comment

In this demonstration, a plus sign (+) indicates brush-mixed colors. These mixes vary naturally and create a more realistic look.

Angel Trumpet

SHARON HAMILTON

MEDIUM: *Acrylic*

COLORS: ***DecoArt JansenArt Traditions:*** *Blue Grey • Burnt Umber • Carbon Black • Dark Grey • Hansa Yellow • Pine Green • Quinacridone Violet • Raw Sienna • Titanium White • Warm White • Yellow Oxide*

BRUSHES: ***Loew-Cornell:*** *Comfort shader, series 3300 - nos. 6, 8, 10, 12 & 14 • Comfort filbert, series 3500 - nos. 8 & 10 • Comfort wash, series 3550 - ¾-inch (19mm) & 1-inch (25mm)*

OTHER SUPPLIES: *Multisurface sealer • Glazing medium • Extender & blending medium*

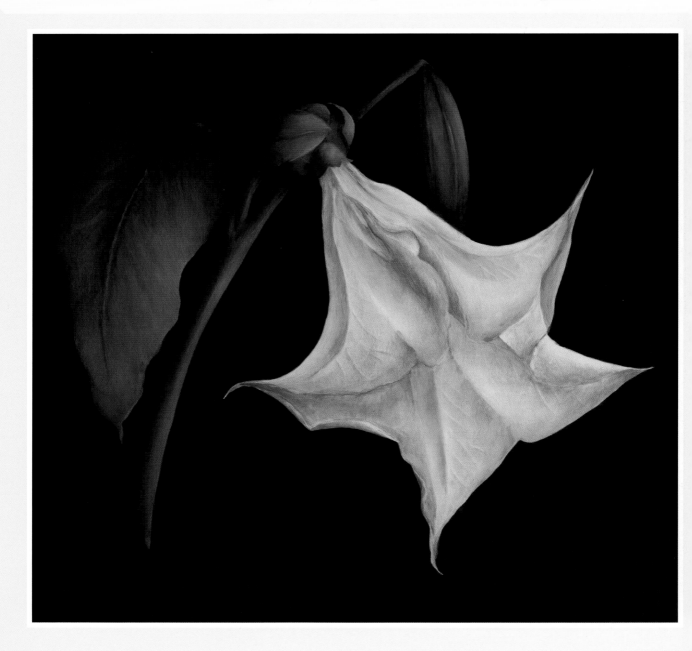

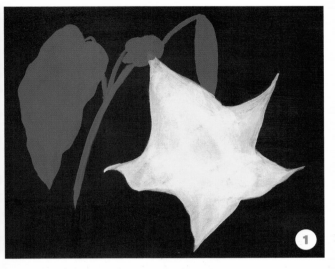

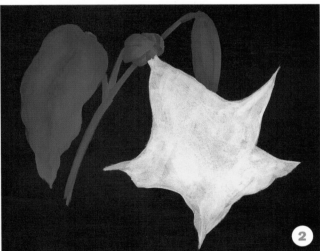

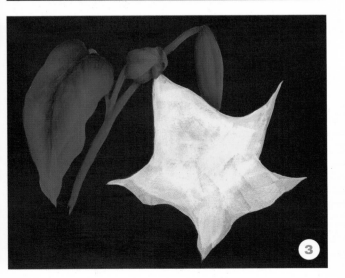

1 Base

For a black background, mix Carbon Black + Blue Grey (1:1) and then mix this with an equal part of sealer. Basecoat the background with a 1-inch (25mm) wash.

Basecoat all the green elements with a no. 14 shader loaded with Pine Green + Raw Sienna + Quinacridone Violet + Warm White (7:2:1:1). Basecoat the flower with a ¾-inch (19mm) wash loaded with Warm White + Hansa Yellow (4:1). Apply a barrier coat of glazing medium to the surface.

2 Shade Green Elements

Side load a ¾-inch (19mm) wash with Pine Green + Raw Sienna + Quinacridone Violet + Warm White (7:2:1:1), and float it along the left, right and back edges of the leaves. Also make a back-to-back float through the center of each leaf. Load a no. 12 shader with the same mix and float it along the left side of all remaining green elements.

3 Deepen Shading

Deepen all the previous floats with Pine Green + Quinacridone Violet + Burnt Umber (7:2:2) loaded onto a no. 14 shader. Use a no. 10 shader for the remaining green elements.

artist's comment

I build my values in steps, which requires the use of glazing medium and extender. The glazing medium seals each layer and adds depth to the painting, while the extender allows longer open time for blending the float before it dries. Be sure to let the extender dry completely before sealing it with glazing medium and proceeding to the next step.

Angel Trumpet

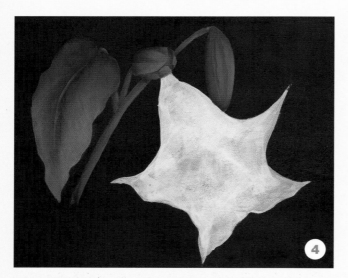

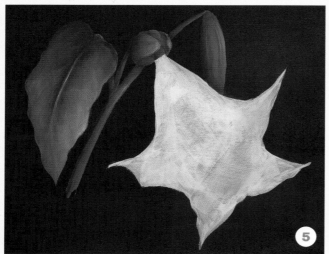

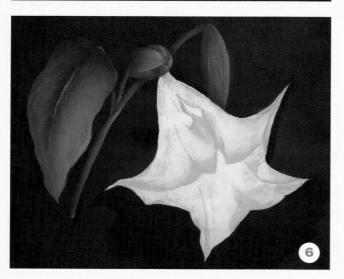

4 Highlight Green Elements

Side load Yellow Oxide + Pine Green + Warm White (4:3:3) onto a no. 14 shader and float the light values on the leaf, stems, pod and bud.

5 Further Highlight and Add Tints

Side load Warm White + Hansa Yellow (1:2) onto a no. 12 shader and float highlights within the previous floats of all the green elements. Side load Quinacridone Violet + Yellow Oxide (1:2) onto a no. 12 shader and float pink tints on the leaf, stem, pod and bud.

6 Color Flower Edges

Side load a no. 14 shader with Warm White + Quinacridone Violet + Hansa Yellow (22:1:1) and float it along the outer edges of the flower. Use a damp no. 8 filbert to blend the soft edge of the float. Repeat the floats with a no. 12 shader loaded with Warm White + Quinacridone Violet + Yellow Oxide (16:2:1). Then go on to deepen the previous floats with Warm White + Quinacridone Violet + Yellow Oxide (8:2:1) loaded onto a no. 8 shader.

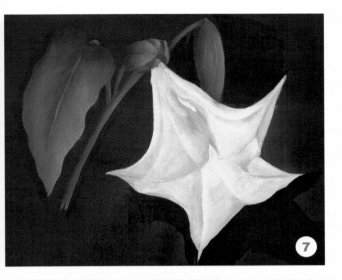

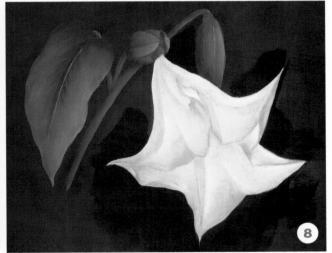

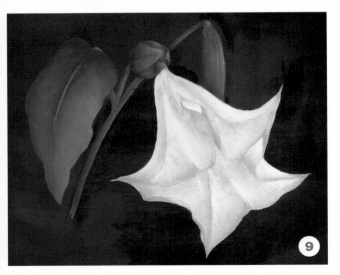

7 Deepen Pink, Edges and Creases

Side load Quinacridone Violet + Pine Green + Warm White (1:2:4) onto a no. 6 shader and deepen the darkest pink areas of the flower. Side load Warm White + Hansa Yellow (8:1) onto a no. 14 shader and float it along the edges and creases and within all the light areas of the flower. Apply a barrier layer of glazing medium and allow it to dry.

8 Add Green Tints and Highlighting

Dress a no. 14 shader with extender and then side load Hansa Yellow + Pine Green (3:1). Add green tints between creases and at the top part of the petal where it meets the lower portion. Blend with a no. 10 filbert. Side load Warm White + Hansa Yellow (15:1) onto a no. 12 shader and build up the light areas on the flower. Side load Warm White onto a no. 10 shader and build up the highlights on the right side of the flower.

9 Add Veins, Strengthen Highlights, Float Shading

Side load Warm White onto a no. 6 shader and float fine vein lines away from the flower creases. Side load Titanium White onto a no. 10 shader and further build up the flower highlights. Apply a layer of glazing medium and allow it to dry. Dress a no. 12 shader with extender and side load Dark Grey onto it. Float it in the darkest shadow areas of the flower. (See photo on page 8 for larger view).

A through C

Apple Blossoms

MARGARET ROSEMAN

MEDIUM: *Watercolor*

COLORS: **Winsor & Newton:** *Winsor Yellow • Scarlet Lake • French Ultramarine*
Holbein: Indian Yellow • Permanent Rose • Manganese Blue

BRUSHES: *Hake - 2-inch (51mm) • Robert Simmons Skyflow wash (synthetic) - 2-inch (51mm) • Flat gold sable (synthetic) - 1-inch (25mm) • Round gold sable (synthetic) - no. 8 • Rigger (synthetic) - no. 4*

OTHER SUPPLIES: *140-1b. (300gsm) cold-pressed watercolor paper*

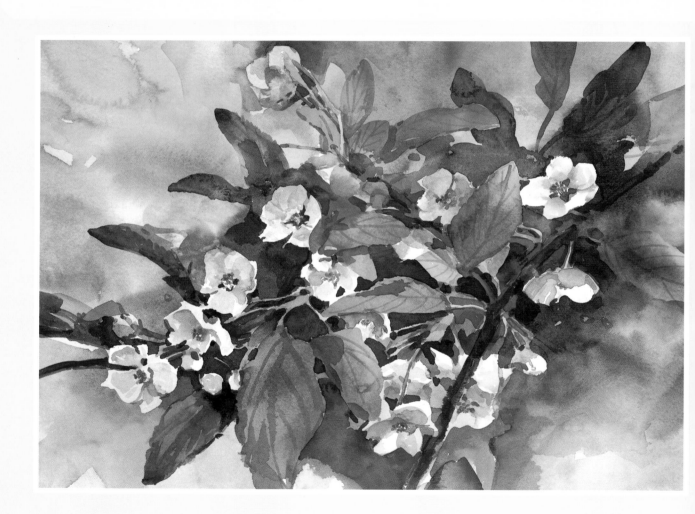

1 Start Background

Using the 2-inch (51mm) hake, generously wet the paper, leaving a dry area for the main image. Let the water absorb a few minutes until you have both shiny and mat areas. Apply a watery Manganese Blue with the 2-inch (51mm) sky flow brush. Make randomly placed strokes, sometimes starting off the paper and touching the surface as you brush inward.

Now double load with watery Winsor Yellow and Indian Yellow. Let these colors mix on the paper rather than blending too much on the palette. Be sure you let some areas of the previous color "peek through."

In the upper right corner, apply a few strokes of a slightly more concentrated mix of Permanent Rose + Manganese Blue + a touch of French Ultramarine. Be sure you have irregular shapes and edges in the inner dry area. Some shapes should be crisp; others should have a soft edge. You may also have some dry-brush areas.

2 Begin Negative Shapes

Switch to the 1-inch (25mm) flat. Apply leaf shapes in a variety of sizes and directions, using a medium consistency of Indian Yellow + Manganese Blue. Some shapes will soften as they mingle with background colors. Start to "carve out" blossom and branch shapes, painting negatively.

As these colors settle, make a dark, somewhat thick, lightly mixed Indian Yellow + French Ultramarine + Scarlet Lake. You should be able to see component colors. Place this color combination in the upper right, sculpting the negative shape of your subject. Carry this dark to accent a few edges in the compositions. Edges next to dry paper will be crisp; those on a damp area will diffuse with previously applied colors.

artist's comment

Repetitive small white shapes tend to make a branch full of white blossoms read as disjointed. Varying the blossom size, creating groupings and paying attention to composition result in a more dynamic representation of the subject.

13

Apple Blossoms

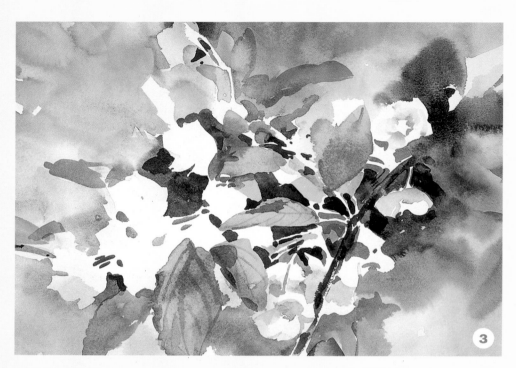

3 Finish Negative Painting, Begin Modeling
Let the paper dry. Using a 1-inch (25mm) flat and a varied, but warm, mix of Scarlet Lake, Indian Yellow, Permanent Rose and French Ultramarine, negatively paint shapes for blossoms and stems. Use the same warm combination of colors and a no. 8 round to define the main branches.

With greens made from Winsor Yellow, Indian Yellow, Manganese Blue and French Ultramarine, paint positive leaf shapes in various sizes and directions to help define the blossoms. While the leaves are wet, paint vein patterns on a few leaves, using a no. 4 rigger. Create a watery mix of Manganese Blue + Permanent Rose + Indian Yellow and start modeling each blossom with a no. 8 round. Alternate the color temperature of the mix from warm to cool.

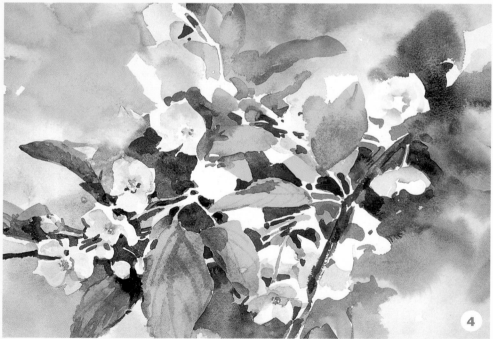

4 Model and Detail Blossoms
Continue modeling each blossom with gray tones. While the color is still damp, drop pure shots of either Winsor Yellow or Indian Yellow into the center of each flower. When these are almost dry, add little dots of Scarlet Lake to define the odd stamen.

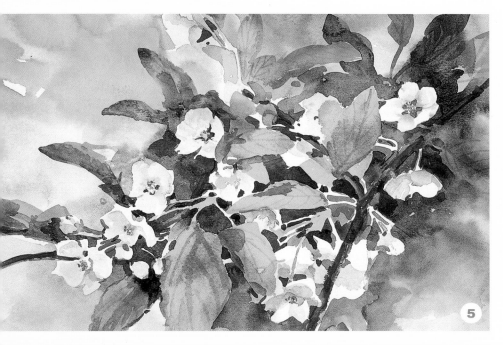

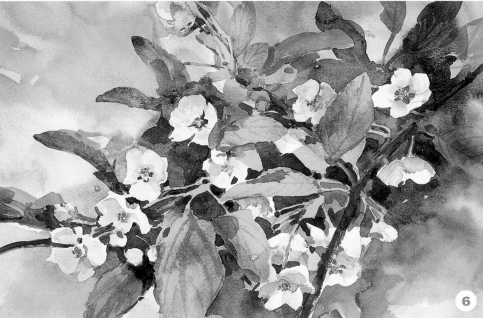

5 Expand Leaves

To carry the design further, expand the leaf pattern by painting on the dry surface with the 1-inch (25mm) flat. This will give you crisp, hard edges, which will need to be softened in places to vary the form. To do this, rinse the brush of color, wipe it in a tissue to remove some moisture and feather the edge of the painted area so the color softly fades.

6 Apply Finishing Touches

To account for the stem shapes created by negative painting, model them with a variety of pale yellow to pale green mixes. Create a sense of spatial dimension by glazing on some cast shadows. On leaves, use a warm green and on some blossoms use a light wash of Manganese Blue to pinkish gray (Permanent Rose + Manganese Blue). Using the rigger, paint a few more vein patterns on the leaves, but don't "overdecorate."

Aster

MARK WILLENBRINK

MEDIUM: *Watercolor*

COLORS: *Cadmium Yellow • Cadmium Orange • Permanent Rose • Quinacridone Violet • Cerulean Blue • Thalo Yellow Green • Thalo Green (Color names may vary from brand to brand.)*

BRUSHES: *No. 14 round (Make sure this brush can make a fine point for painting around the petals. A larger brush may be used for the background.)*

OTHER SUPPLIES: *140-lb. (300gsm) cold-press watercolor paper for 9" x 18" (23cm x 46cm) image • 2B pencil • Kneaded eraser • Optional items (see step 1): Masking tape • Sturdy board*

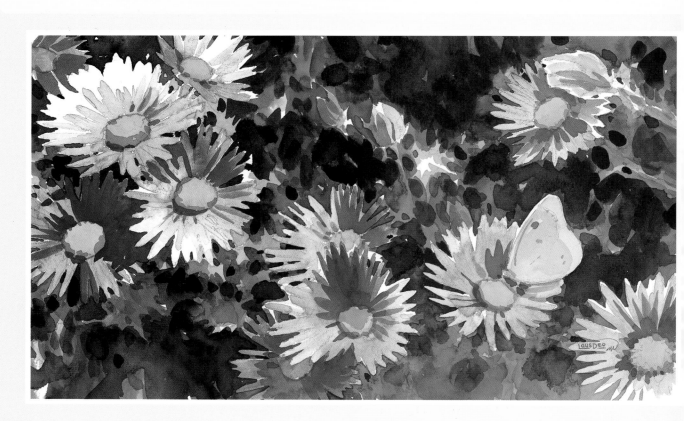

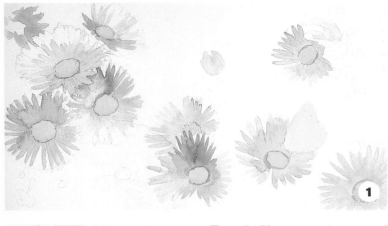

1 Base Flowers

If you are not using watercolor paper in block form, secure your paper to a sturdy board with masking tape. Draw the flowers on the paper with a 2B pencil.

Paint the flower centers and the butterfly with Cadmium Yellow and Cadmium Orange. Paint the flower petals with Permanent Rose, Quinacridone Violet and Cerulean Blue, leaving them light in some places and darker in others.

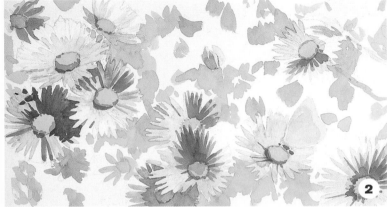

2 Add Darker Flower Values, Begin Background

Add darker values to the petals with Permanent Rose, Quinacridone Violet and Cerulean Blue. Paint darker values to flower centers with Cadmium Yellow, Cadmium Orange and Permanent Rose. Paint lighter green background colors with Thalo Yellow Green and Cerulean Blue.

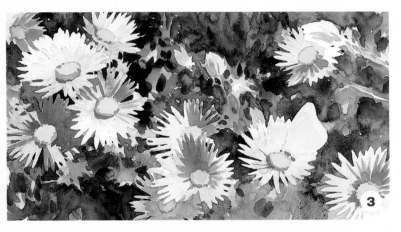

3 Add Darker Background Values

Paint darker background colors with Thalo Yellow Green, Thalo Green, Cerulean Blue and Quinacridone Violet. Varying these colors and their darkness and intensity adds to the interest of your painting.

4 Add Finishing Touches

Paint remaining details and adjustments by going darker in a few places. Erase pencil lines. Then sign and date your painting.

artist's comment

When mixing your paints, try to vary your colors so that your painting has a looser, more natural look.

Azalea

MARY SPIRES

MEDIUM: *Watercolor*

COLORS: ***Daler-Rowney Artists' Water Colour:*** *Alizarin Crimson • Burnt Sienna • French Ultramarine • Gamboge*

BRUSHES: ***Robert Simmins by Daler-Rowney:*** *Skyscraper • No. 8 round • No. 4 script*

OTHER SUPPLIES: *140-lb. (300gsm) watercolor paper • Masking fluid*

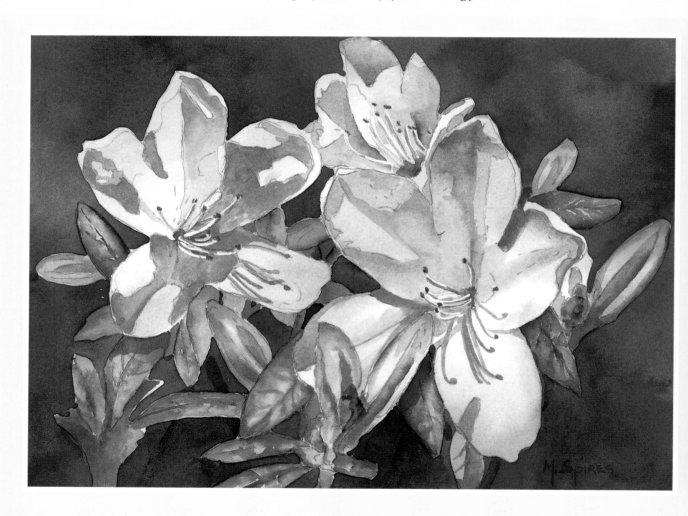

1 Mask Stamens and Tint Paper

Apply masking fluid on the stamens and let dry (it will feel tacky). Wet the paper with water until it is saturated. Using a Skyscraper brush, drop in Alizarin Crimson + French Ultramarine Blue and French Ultramarine Blue + Gamboge. Pick up the paper and allow the colors to blend. The values should be light—just enough to tint the paper.

2 Define Shadow Shapes

Using a no. 8 round, wet the shadow areas of the petals with water. Drop in French Ultramarine Blue + Burnt Sienna and Alizarin Crimson + French Ultramarine Blue. This gives the petals their form.

3 Glaze

Once you've completed all the petal shadow shapes, paint the buds with a light value of Alizarin Crimson + French Ultramarine Blue. Paint the leaves Gamboge + French Ultramarine. Paint the stems Burnt Sienna.

4 Strengthen Shadows, Paint Veins

Paint another layer of French Ultramarine Blue + Burnt Sienna in the shadow areas to separate and define the shapes. Paint the veins French Ultramarine Blue + Gamboge, using a no. 4 script.

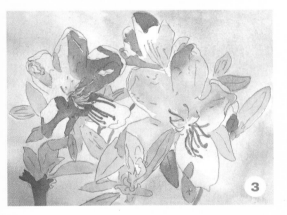

5 Detail and Define

(See completed painting on opposite page.) Continue adding shadow layers until you get the desired values. Remove the masking fluid. Using a no. 4 script, paint a shadow in the stamens and then add tips of Burnt Sienna. Mix dark values of French Ultramarine Blue + Alizarin Crimson, French Ultramarine Blue + Burnt Sienna and French Ultramarine Blue + Gamboge. With a no. 8 round, starting at the bottom and working your way around the background, wet the paper with water. Then drop in the three colors, letting them bleed and blend.

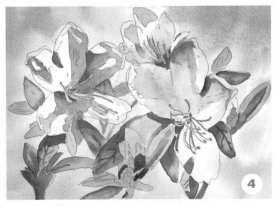

artist's comment

I like shooting floral reference photos in early morning light, which enables me to get strong shadows and light patterns.

Bellflower

MARGARET ROSEMAN

MEDIUM: *Watercolor*

COLORS: ***Winsor & Newton:*** *Winsor Yellow • French Ultramarine Blue*
Holbein: *Indian Yellow • Manganese Blue • Verditer Blue • Peacock Blue*
Daler-Rowney: *Quinacridone Magenta*

BRUSHES: *Round gold sable (synthetic) - nos. 5 & 8*

OTHER SUPPLIES: *HB pencil • Masking fluid*

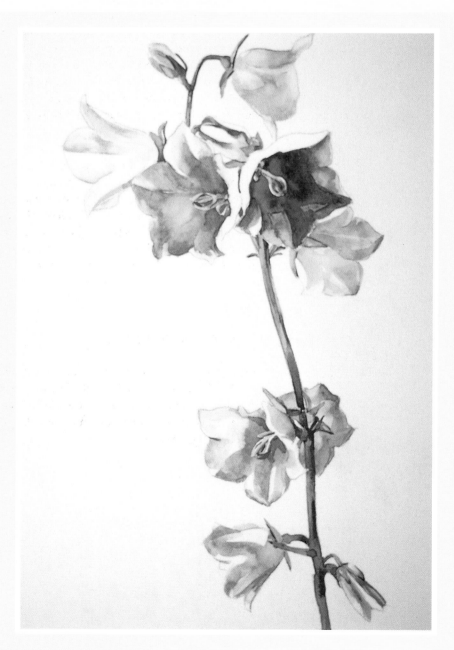

1 Paint Flowers

Using an HB pencil, lightly draw the flower outline. Apply masking fluid to the stamens and let dry thoroughly.

Paint each flower and bud with a no. 8 round and watery paint. Start with Winsor Yellow or Indian Yellow and then introduce light washes of Verditer Blue, Manganese Blue and Peacock Blue, as well as shades of mauve derived by mixing these blues with Quinacridone Magenta. Let the colors mix on the paper. Paint the inside of the flower on the right with a stronger value of the above colors.

2 Reinforce Color, Start Stem

If the right flower has dried back a little too much, darken the value by painting the area again. Let dry and then remove the masking fluid from the stamens.

Start modeling the stem, using a no. 5 round with bright greens mixed from Winsor Yellow + Peacock Blue and Winsor Yellow + Manganese Blue. Darker greens are derived from blending Indian Yellow and French Ultramarine Blue.

3 Complete Stem, Paint Stamens

(See completed painting on opposite page.) Continue to account for the rest of the stem by varying the yellow-greens and blue-greens, changing the values along the length. An occasional "shot" of a warm mix of Indian Yellow + Quinacridone Magenta creates a more realistic image. Paint stamens with warm colors, using the two yellows and the Indian Yellow + Quinacridone Magenta mix.

artist's comment

It's amazing how many colors are used to represent "white"! Conveying the form of white flowers takes a multitude of primary color combinations. Varying the values of these colors also intensifies the quality of light on the subject.

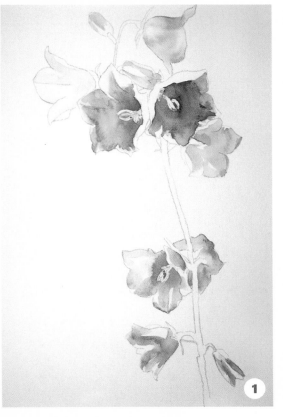

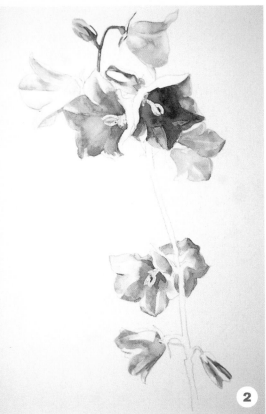

Black-Eyed Susan

JANE MADAY

MEDIUM: *Watercolor*

COLORS: **Holbein:** *Raw Umber • Cadmium Yellow Light • Sap Green • Burnt Umber • Sepia • Olive Green • Hooker's Green*
Winsor & Newton: *Indian Yellow*

BRUSHES: **Silver Brush Limited:** *Ultra Mini Designer Round, series 2431S - nos. 6 & 12 • Debbie Cole Dry Blending, series 2100S, no. 5*

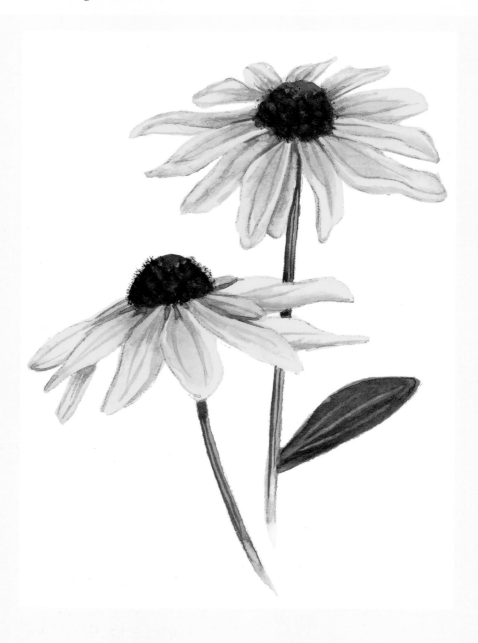

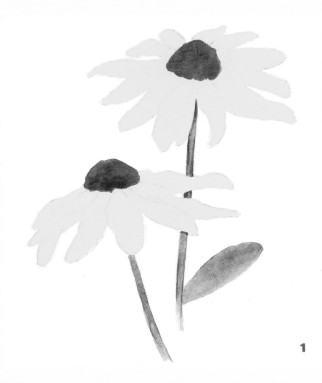

1

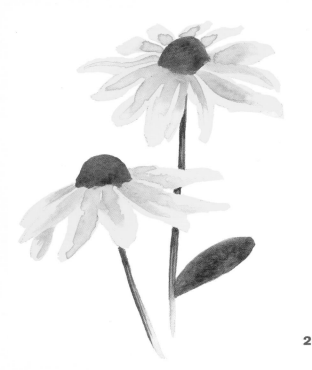

2

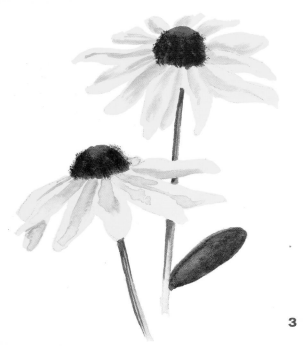

3

1 Base

Sketch the flower and then basecoat with a no. 12 Ultra Mini round. Use Cadmium Yellow Light for petals, Burnt Umber for flower centers and Sap Green + Olive Green (1:1) for stems and leaf. Let each area dry before you paint one that is next to it.

2 Shade

With the same brush, add some Indian Yellow to the petals, starting at the flower center and blending outward. Shade the stems and leaf with Hooker's Green + Burnt Umber (2:1).

3 Stipple

Using a no. 5 dry blending brush, stipple Sepia into the flower centers, leaving an unstippled spot in the very center. Let the stippling overlap the edges of the centers for texture.

4 Detail

(See completed painting on opposite page.) Using a no. 6 Ultra Mini round, detail the petals with Raw Umber, adding some Burnt Umber sparingly for darkest touches. Dot Cadmium Yellow Light around the unstippled area in the flower centers. Add a touch of Burnt Umber where the leaf touches the stem. Let dry, and then pull out light veins on the leaf, using a no. 6 Ultra Mini round that's moistened (but not dripping wet) with clean water.

artist's comment

The color on black-eyed Susans is intense. Be sure you don't add too much water to the yellow paint.

Calla Lily

ERIN O'TOOLE

MEDIUM: *Gouache*

COLORS: **Winsor & Newton Designers Gouache:** *Permanent White • Cobalt Blue • Ultramarine • Primary Yellow • Marigold Yellow • Burnt Sienna • Olive Green • Raw Sienna*

BRUSHES: **Isabey:** *Kolinsky sable - no. 6*

OTHER SUPPLIES: *Niddegan paper (for brown background) • Dr. Martin's Bleed Proof White*

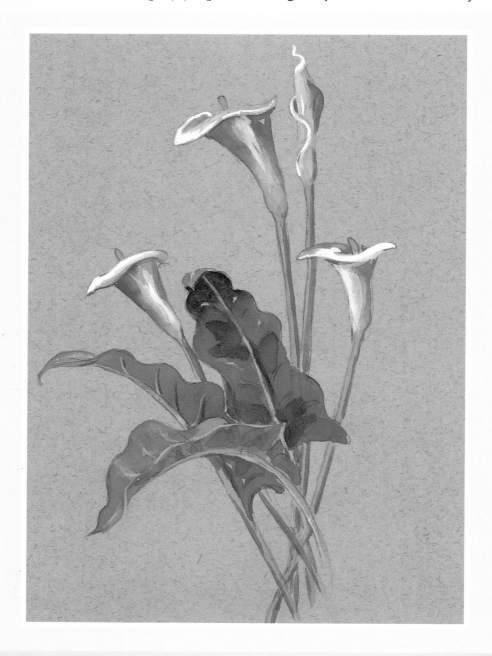

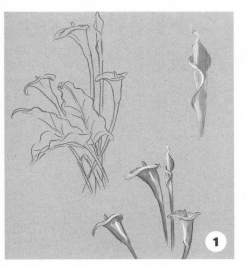

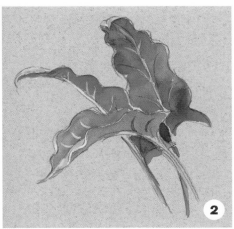

1 Draw Sketch, Begin Painting Flowers

Make a pencil sketch of the lily. Follow the stems out to be sure the stamen is in the right place and the leaves fold properly. Lighten the pencil lines with a kneaded eraser.

Now outline the lightest spots of the flowers with Permanent White. The flower shadows are Cobalt Blue with Raw Sienna and some white. The stems are a light green mix of Primary Yellow + Cobalt Blue. Paint the bud with a pale blue shadow and a spiral of white leading up to the tip.

2 Begin Leaves

Begin the leaves in the shadow areas. A dark wash of Ultramarine + Burnt Sienna starts under the tip, with Cobalt Blue and Olive Green added as you go down the leaf. Leaf veins are yellow + white. Paint the upward-facing parts of the leaves with Primary Yellow, Olive Green and a touch of white. The line of the stem goes from the top of the leaf through to the underside in one swoop.

3 Strengthen Whites and Shadows

Add another coat of white on the flowers to make them glow. Add another coat of Olive Green and Cobalt Blue to the leaf shadows. Leave the flower stems lighter. Erase the pencil lines.

4 Apply Finishing Touches

(See finished painting on opposite page.) Finish with a light yellow-green where the flowers meet the stems. Apply a coat of Dr. Martin's Bleed Proof White on the highlights along the flower and bud edges.

artist's comment

When drawing calla lilies from life, sketch them quickly, because they move with the light.

25

Chrysanthemum

SHARON HAMILTON

MEDIUM: *Acrylic*

COLORS: ***DecoArt JansenArt Traditions:*** *Blue Grey • Carbon Black • Chrome Green Hue • Hansa Yellow • Light Violet • Raw Sienna • Raw Umber • Red Violet • Warm White*

BRUSHES: ***Loew-Cornell:*** *Comfort shader, series 3300 - nos. 6, 8, 10, 12 & 14 • Comfort wash, series 3550 - 1-inch (25mm)*

OTHER SUPPLIES: *Multi-surface sealer • Glazing medium • Extender & blending medium*

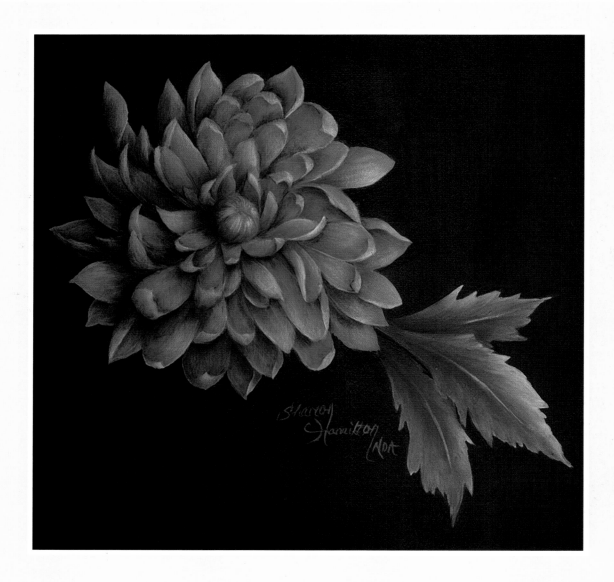

1 Base

For a black background, mix Carbon Black + Blue Grey (1:1) and then mix this with an equal part of sealer. Basecoat the background with a 1-inch (25mm) wash.

Load a no. 12 shader with Raw Sienna + Chrome Green Hue + Warm White + Raw Umber (5:2:2:1) and basecoat the leaves. Load a no. 14 shader with Red Violet + Light Violet + Raw Sienna + Warm White (3:2:1:1) and basecoat the flower.

2 Deepen Leaf Centers

Side load a no. 12 shader with Raw Sienna + Chrome Green Hue + Warm White + Raw Umber (4:2:1:1) and make a back-to-back float through the center and at the base of each leaf. Side load a no. 10 shader with Raw Sienna + Chrome Green Hue + Raw Umber (3:2:1) and repeat the floats. Add a barrier coat of glazing medium.

artist's comment

To set up a wet palette, start with a folded Scott Shop Towel soaked in water. Squeeze out a little of the water and then place the towel on top of a waxed palette. While working, I mist my paints frequently to keep them from drying out. If I have to leave my work, I cover my palette with plastic wrap.

Chrysanthemum

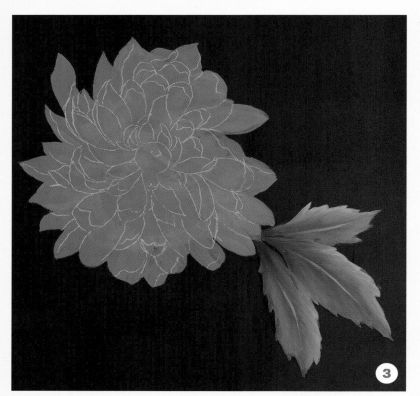

3 Detail Leaves

Dress a no. 10 shader with extender and then side load Warm White + Raw Sienna + Chrome Green Hue + Hansa Yellow (3:5:1:1). Float the mix along the outer edges of the leaves. Reload the brush and use the chisel edge to pull the center vein. Dress a no. 8 shader with extender and side load Warm White + Hansa Yellow (5:1) + the tiniest bit of Chrome Green Hue. Float this mix within the previous floats. Thin Red Violet with extender and add tints to the leaf edges.

4 Start Petals

Side load Red Violet + Light Violet + Raw Sienna + Warm White (3:2:1:1) onto a no. 8 shader and float it in the dark areas of the petals. Side load a no. 6 shader with Red Violet + Raw Umber (5:1) and repeat the floats. Deepen the dark areas further with Red Violet + Raw Umber (5:1).

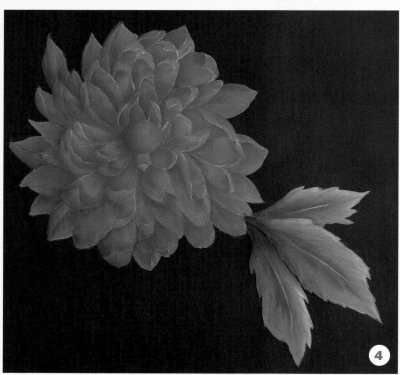

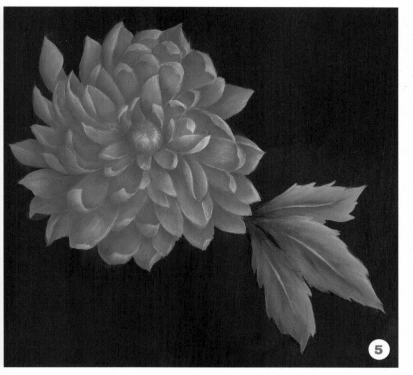

5 Highlight Petals

Dress a no. 8 shader with extender and then side load Warm White + Light Violet (2:1) + the tiniest bit of Hansa Yellow. Float the mix on the light edges of the petals. Side load a no. 6 shader with Warm White + Light Violet (15:1) + the tiniest bit of Hansa Yellow and repeat the floats. Then add a barrier coat of glazing medium.

6 Add Tints and Petal Shadows

Dress a no. 8 shader with extender and a little Hansa Yellow. Add yellow tints to the right side of the mum and leaves. Dress a no. 6 shader with extender and side load Carbon Black. Add the cast shadows to the left of each of the petals.

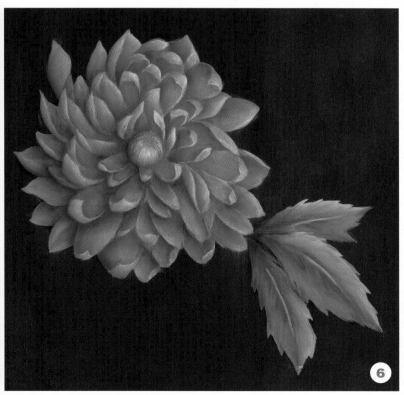

Cornflower

BRIGITTE SCHREYER

MEDIUM: *Watercolor*

COLORS: **Winsor & Newton Artists' Water Colour:** *New Gamboge • Permanent Rose • Cobalt Blue • Antwerp Blue • Raw Sienna • Burnt Sienna*

BRUSHES: *Flat - 1½-inch (38mm) • Round - no. 8*

OTHER SUPPLIES: *140-lb (300gsm) cold-pressed watercolor paper • 2H pencil*

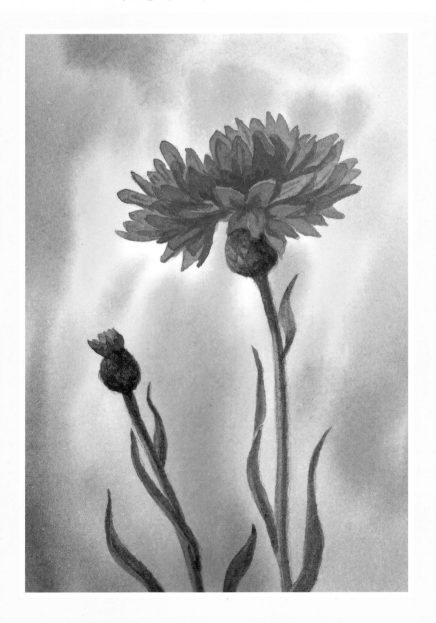

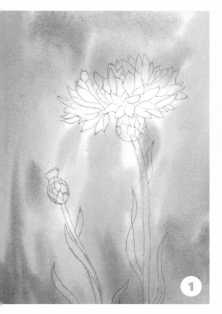
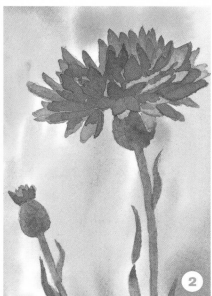
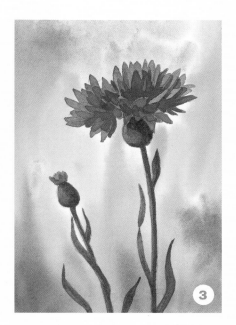

1 Sketch Flower, Paint Background

Sketch in the flower with a 2H pencil. Avoid pressing too hard and denting the paper. Wet the paper with a 1½-inch (38mm) flat so the surface is only lightly shiny and water doesn't run off the corners when the paper is tilted.

For the rest of the painting, use a no. 8 round. Prepare even puddles of thinned-down New Gamboge, Permanent Rose and Cobalt Blue, as well as a light green mixture of New Gamboge + Antwerp Blue. Drop these colors onto the wet surface for a background resembling a blurred garden. Avoid the flower head. Add a little Raw Sienna to the green mix and make a few upward strokes in the foreground. Let dry completely.

2 Wash Flower and Bud, Paint Petals

Wash the flower head and the bud top with watery Cobalt Blue. Then mix Raw Sienna + a little Antwerp Blue in two different strengths—one warmer and heavier on the Raw Sienna and one cooler. Paint a flat wash onto the stems and leaves and under the flower head and the bud. Let dry.

Paint a layer of small petal-like strokes with a less watery Cobalt Blue, leaving a bit of the first layer exposed. Be sure your brush has a good point. Add a little Cobalt Blue to the lower part of the emerging bud flower. Let dry.

3 Add Darks and Lights

With Cobalt Blue + a touch of Permanent Rose, paint another layer of petals, skipping some strokes of the former layer. Apply Antwerp Blue + a bit of Raw Sienna to the right of the bud and of the green "bulb" under the flower head. Blend the inside edge with a damp (not wet) brush to suggest roundness. Also apply this mix to the stems and leaves to suggest a light source from the top right.

4 Apply Finishing Touches

(See finished painting on opposite page.) Create more detail by adding another layer of Cobalt Blue + a touch of Permanent Rose, mostly into the petal creases and at the top of the flower head. Use a little pure Burnt Sienna to paint a zigzag pattern on the bud and the flower head "bulb."

artist's comment

Building petal layers of different values gives the flower depth and realism.

Crocus

BONNIE FREDERICO

MEDIUM: *Oil*

COLORS: ***Winsor & Newton Artists' Oil Colour:*** *Titanium White • Cadmium Yellow Pale • Yellow Ochre • French Ultramarine • Alizarin Crimson • Dioxazine Purple • Ivory Black*

BRUSHES: *Filbert - nos. 2, 4 & 6 • Flat - no. 6 • Liner - no. 0*

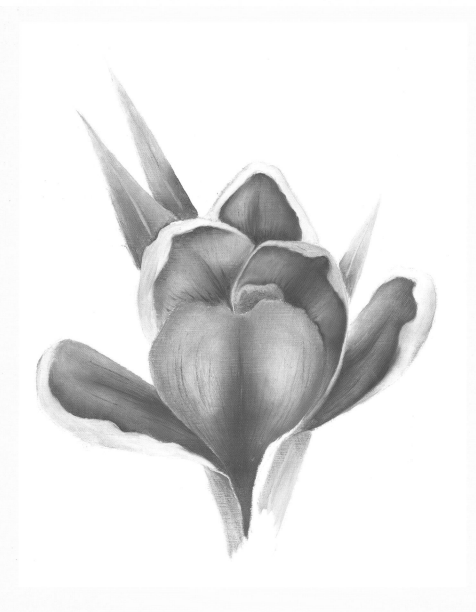

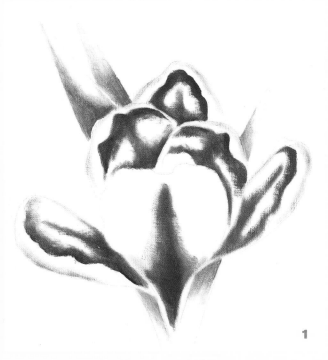

1 Apply Dark Values

Paint the dark shadow areas. Use Dioxazine Purple + Yellow Ochre + Titanium White on the crocus and Cadmium Yellow Pale + French Ultramarine + Ivory Black on the leaves.

2 Apply Medium and Light Values

Add white to your mixes to create medium and light values (the more white, the lighter the value). Apply these medium and light values and blend, making sure you maintain a good value change.

3 Paint Finishing Details

(See completed flower on opposite page.) Add vein work on the petals and the leaves. Then tap yellow on the crocus center. Add Cadmium Yellow Pale + Alizarin Crimson (orange). Then deepen with a mix of the orange + Dioxazine Purple.

1

artist's comment

I always intend to paint spring crocuses when they're peeking through the snow, but I never find time. Instead, I take photos and notes to refer to when I have time to paint.

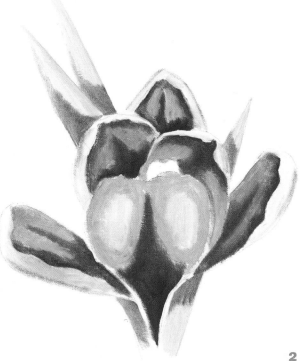

2

Dandelion

GAYLE LAIBLE

MEDIUM: *Watercolor*

COLORS: ***MaimeriBlu Watercolors:*** *Primary Yellow • Primary Red • Yellow Ochre • Ultramarine Light • Burnt Umber*

BRUSHES: ***Dynasty Watercolor Brushes:*** *Glaze/Wash, Black Gold Series 206FW - ¼-inch (6mm), ½-inch (13mm) & ¾-inch (19mm) • Round, Camelot Series 4000 - nos. 2, 4 & 8*

OTHER SUPPLIES: *Masquepen or masking fluid • Wooden skewer or stylus (to apply masking fluid) • Rubber cement pick up (optional)*

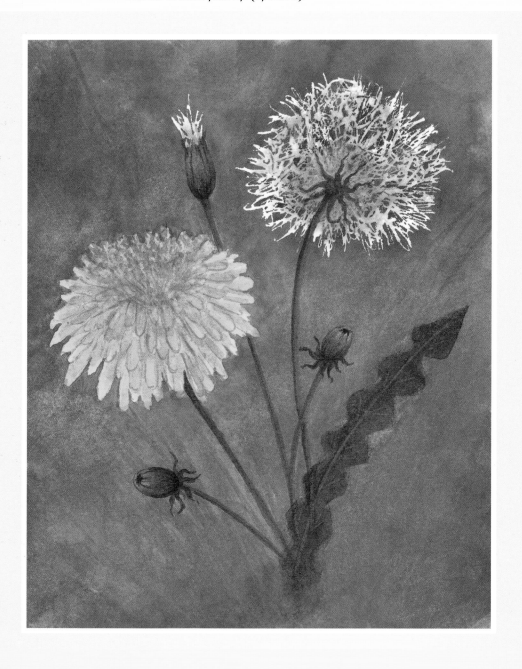

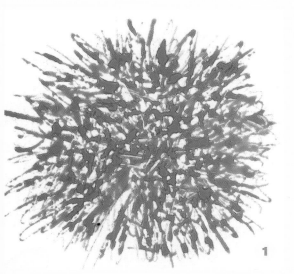

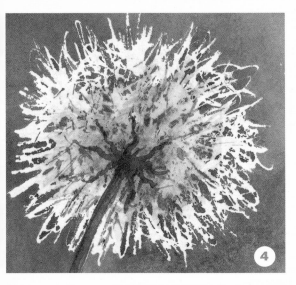

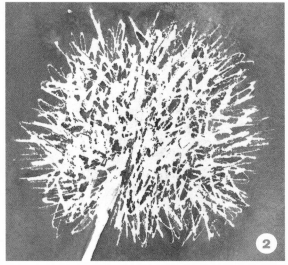

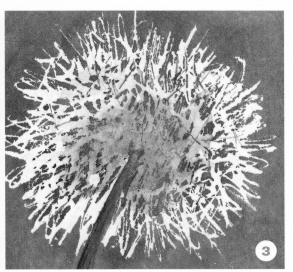

1 Mask Seed Ball

Using a Masquepen or a wooden skewer or a stylus, paint the seed ball in masking fluid. Think of fireworks or a little starburst. Place more masking fluid where the stem attaches to the seed ball. Also mask the petals emerging from the top bud (see finished painting on opposite page). Let the mask dry completely!

You may mask the rest of the flower before you paint the background or paint around it. If you run over the edges, let the background dry and then wipe out the darkest color with a damp brush.

2 Paint Background

Paint the background dark enough for the seed ball to show up after the masking has been removed. Use a green mix of Ultramarine Light + Primary Yellow + a touch of Primary Red. For a darker value, add Burnt Umber. Let dry.

3 Apply Wash, Paint Stem

Remove the masking fluid with a rubber cement pickup or by carefully rubbing with your fingers. Apply a light wash of a thinned green mix around the stem. Then apply a thinned orange/red mix of Yellow Ochre + a touch of Primary Red and Burnt Umber in the same area. The stem is darker green on the left and orange/red on the right.

4 Paint Calyxes

Paint all the calyxes with a darker green, pulling out from the stem. Note that you are looking at the back of the seed ball. Accent with a little orange/red mix.

Dandelion

5

6

7

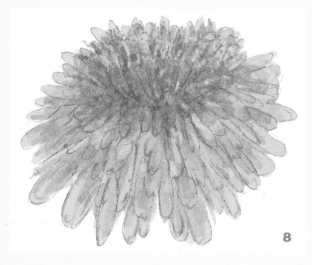

8

5 Base, Begin Petals
Wash a yellow mix of Primary Yellow + a touch of Yellow Ochre over the entire flower. Let dry. Using a ½-inch (13mm) wash and the same yellow mix, pounce or chop in illusions of petals. Hold your brush vertical to the paper.

6 Add Petal Layers
Pounce in more petal layers with a Yellow Ochre wash. Add a touch of Primary Red to the Yellow Ochre and pounce in a few more petal layers. Strive for the look of layers upon layers of petals.

7 Add Darker Values
Use a ¼-inch (6mm) wash to pounce a little green mix (Ultramarine Light + Primary Yellow + a touch of Primary Red) about one-third from the top of the flower, creating the illusion of shadow where the petals change direction. Add a little more Primary Red to the yellow mix and pounce in a few more lower petals. Let the various color values show.

8 Paint Center Petals, Outline
Pounce the orange/red mix on the upper third of the flower. These petals are shorter and choppier. Pounce dots on top of the petals in the flower center. Use your no. 2 round to outline random petals for separation.

9 Shade Green Elements

Wash green mix over and around the spot on top of the buds and on down the buds, staying lighter at the tops. Also wash green mix on the calyxes, and the leaf. Darken the center of the leaf, the bottom of the buds, the spot at the top of the buds and the base of the calyxes with the same green mix. (Add Burnt Umber if the green mix needs to be darker.)

10 Add Finishing Touches

Wash orange/red mix over the right side of the buds. Use green mix to darken the left side of the bud bottoms. Pull little lines up from the bottom of these buds. Also darken the left side of the calyxes and leaf and the center of the leaf. Dip a ¼-inch (6mm) wash in clean water, blot and wipe away leaf veins. Accent the leaf edges and calyxes with orange/red mix.

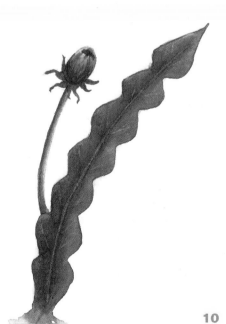

9

10

artist's comment

The green background in this painting suggests grass or underbrush. A blue background would suggest sky.

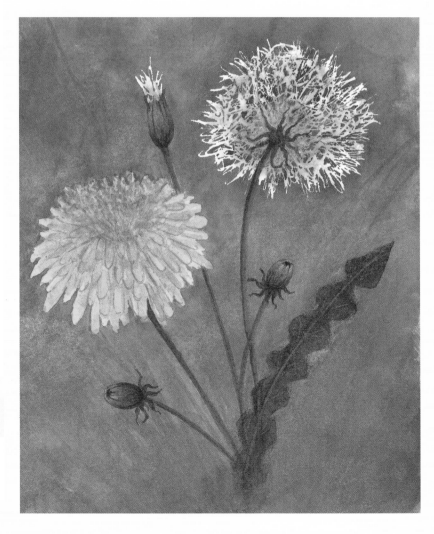

Forget-Me-Not

LINDA KEMP

MEDIUM: *Watercolor*

COLORS: ***Holbein Artists' Water Color:*** *Cerulean Blue • Raw Sienna • Rose Violet • Bamboo Green • Marine Blue*

BRUSHES: *Soft flat wash - 1-inch (25mm) • Round - nos. 10 & 12*

OTHER SUPPLIES: *8" x 10" (20cm x 25cm) good quality cold-pressed watercolor paper*

artist's comment

This painting uses a negative painting technique, well-suited for these delicate sprays of forget-me-nots. Keep your shapes simple and flat, and remember to build one layer at a time.

1 Prepare a Loose Underpainting

Stroke clean water over your paper with a soft flat brush. Use a no. 12 round to drop fresh Cerulean Blue combined with Rose Violet to varying degrees onto the paper. Mingle Cerulean Blue with Raw Sienna and stroke it onto the lower portion of the underpainting. Fresh paint that has not been overly diluted or overblended works best to retain a variety of hues within the color. Let dry. You can soften the color by misting the paper with water and tipping it.

2 Establish the First Flower Layer

Sketch a few flowers onto the dry paper. Keep the forms simple and separate from each other. When you paint, you will fill in the space and build dimension with subsequent flower layers.

3 Paint in the Negative Space

When working in the negative, you paint around the flowers instead of filling them in with color. Mix Cerulean Blue + Rose Violet with enough water to create a delicate glaze. Surround each flower and pull the color away by diluting with additional water. Let dry.

Forget-Me-Not

4 **Build a Second Layer**
Draw new flowers, tucking them under or behind the first layer. Take care not to draw over your original shapes. Be sure that you include small, medium and large flowers in your bouquet.

5 Glaze in the Negative Space
Using a large round brush, once again paint around all the flowers with well-thinned Cerulean Blue + Rose Violet (mixed to varying degrees). Let your painting dry completely.

6 Add Leaves, Stems and More Flowers
Pencil in additional flowers. Each new layer is added behind the previous forms. Add gracefully curving stems and a few simple leaves. Glaze around the flowers with Cerulean Blue + Rose Violet. Combine Raw Sienna with Cerulean Blue to paint around the stems and leaves. Soften and blend the colors by adding a little more water.

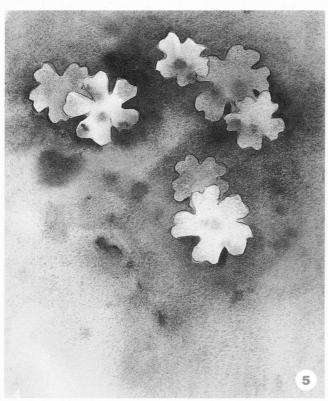

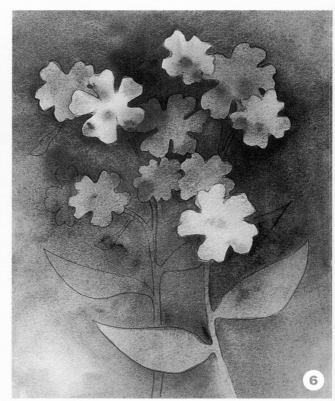

7 Fill Page with Floral Forms

Continue to add blossoms, leaves and stems, remembering to tuck the new shapes behind any and all existing forms. Paint around all your shapes. Each successive glaze will become darker as you establish the multiple layers. Introduce Bamboo Green and Marine Blue into the color mix to provide rich, deep darks. To maintain crisp edges and shapes, dry your painting well between every layer.

8 Add Negative Flower Centers

With negative painting, as long as you make good shapes with descriptive edges, there is no need to go back into your flowers or leaves to add details. However, if you wish to add more dimension or form to a few flowers, add centers by glazing around a small circle with well-diluted Cerulean Blue. Soften any unwanted hard edges with clean water.

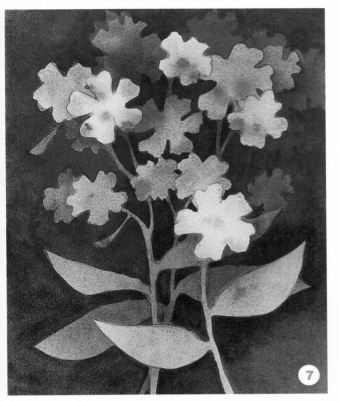

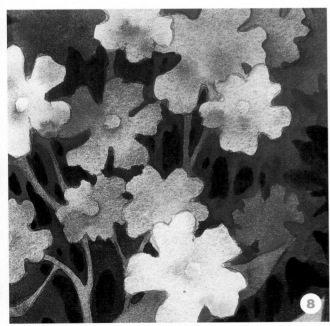

Hibiscus

SANDY KINNAMON

MEDIUM: *Watercolor*

COLORS: **Winsor & Newton Artists' Water Colour:** *New Gamboge • Cobalt Blue • Burnt Sienna • Winsor Red • Winsor Green*

BRUSHES: **Loew-Cornell:** *Wash, series 7150 - ½-inch (13mm) • Round, series 8000 - nos. 4 & 6*

OTHER SUPPLIES: *No. 2 pencil • Straightedge or ruler • Kneaded or white plastic eraser • Razor blade • No. 810 ¾-inch (19mm) Scotch Tape • 2 water containers*

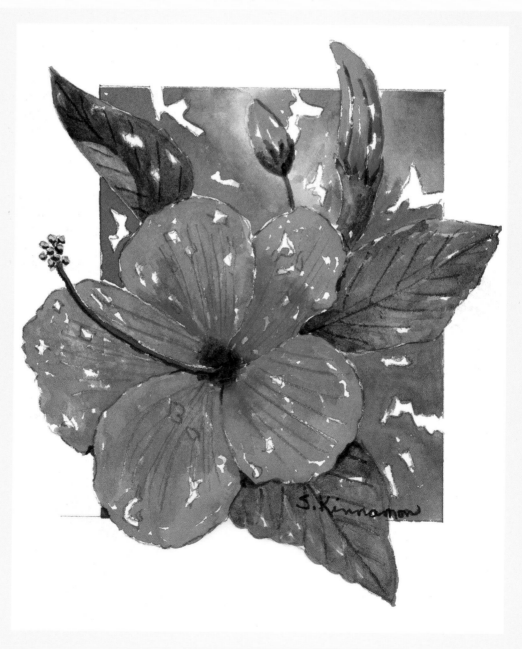

1 Paint Leaves

Mix a large puddle of Winsor Green + New Gamboge. Add New Gamboge to a portion of this green to make yellow-green. Add Winsor Red to a portion of the original green mix for a darker, more muted green. Using the light green on a no. 6 round, paint one leaf at a time, adding other greens as needed and leaving white paper specks. While the paint is wet, scratch in veins with a razor blade corner.

2 Paint Flower

Mix a large puddle of Winsor Red. Add New Gamboge to a portion to make red/orange. And a touch of Winsor Green to another portion to mute and darken. When the paper is dry, paint one petal at a time with a no. 6 round. Start on the outside edge, which is usually lightest, and leave specks of paper showing. While the paint is wet, scratch in veins.

Paint the stamen stem with Burnt Sienna + Cobalt Blue on a no. 4 round. Paint the anther New Gamboge, using the brush tip. Mix a small puddle of very dark Winsor Green + Winsor Red and add a few accents to leaves and flowers. Add a hint of this dark color under each anther.

3 Paint Background

Let dry completely and then mask the background edge with tape, going right over the flowers or leaves that cross the border. Press tape edges firmly to avoid seepage. Mix a puddle of Burnt Sienna and a puddle of Cobalt Blue. Referring to the photo, place colors with a clean, damp brush and soften into the background. Rinse between colors.

artist's comment

If you don't have enough contrast when the flowers are completed, add color to the dry petals where needed, blending with a clean, damp brush. Pull the color out toward you, turning the paper as necessary.

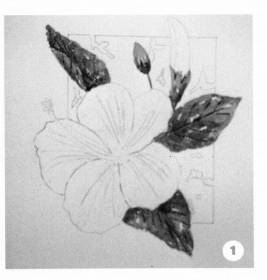

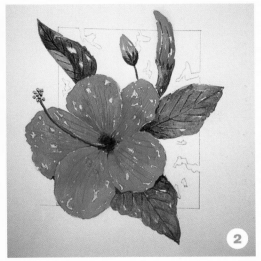

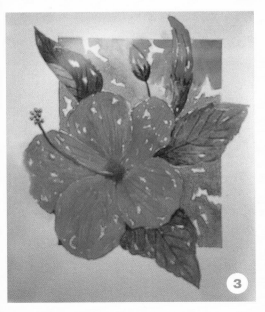

Hollyhock 1

CAROL COOPER

MEDIUM: *Watercolor*

COLORS: **Daniel Smith Extra Fine Watercolors:** *Quinacridone Pink • Rich Green Gold • Undersea Green • Carbazole Violet*

BRUSHES: *No. 8 round (natural hair)*

OTHER SUPPLIES: *140-lb. (300gsm) cold-pressed watercolor paper • HB pencil*

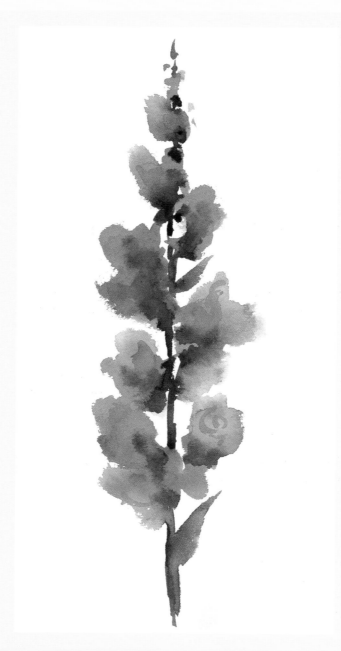

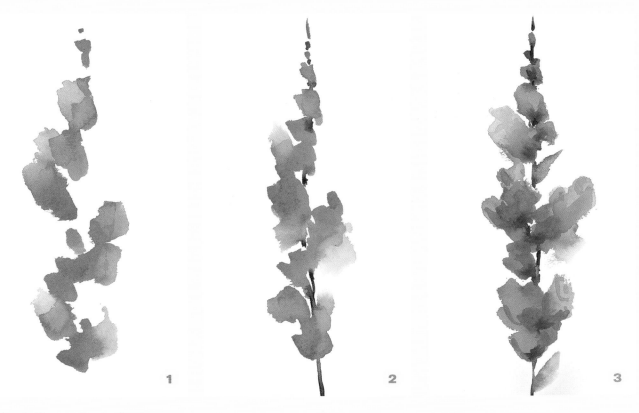

1 2 3

1 Sketch Flower, Begin Petals

Lightly sketch the flower. Apply Quinacridone Pink to the petals, using the body of the brush. Immediately soften a few petals with water.

2 Paint Stem

While the paint is still wet, create the stem by weaving Rich Green Gold up through the flower petals. Allow some green to seep into the pink petals. Darken some of the stem with Undersea Green.

3 Add Leaves, Deepen Petals

While the stem is still somewhat wet, wisp out a few small leaves. Let dry. Then, to add depth to the petals, add another layer of Quinacridone Pink to the petals, allowing some of the initial pink to show through.

4 Build Contrasts

(See completed painting on opposite page.) For more shadows and contrast, while the paint is still wet, add Carbazole Violet to the bases of the flowers at the stem.

artist's comment

Hollyhocks are great painting subjects, either as stars of the show or back-up. Their tall presence is a statement of color and beauty. Every phase of an unfurling blossom speaks of mystery, potential and grace.

Hollyhock 2

PENNY SOTO

MEDIUM: *Watercolor*

COLORS: **Holbein:** *Permanent Red • Cadmium Red Orange • Peacock Blue • Opera*
Winsor & Newton: *Alizarin Crimson • Winsor Violet • French Ultramarine • Indigo • Permanent Sap Green • Payne's Gray • New Gamboge • Chinese White*
Sennelier: *Tyrian Rose • Quinacridone Purple*
Grumbacher: *Thalo Yellow Green*

BRUSHES: *Princeton round bristle, series 6300 R - no. 6 • DaVinci Top Acryl - no. 10 • Princeton flat bristle, series 6300 B - no. 4*

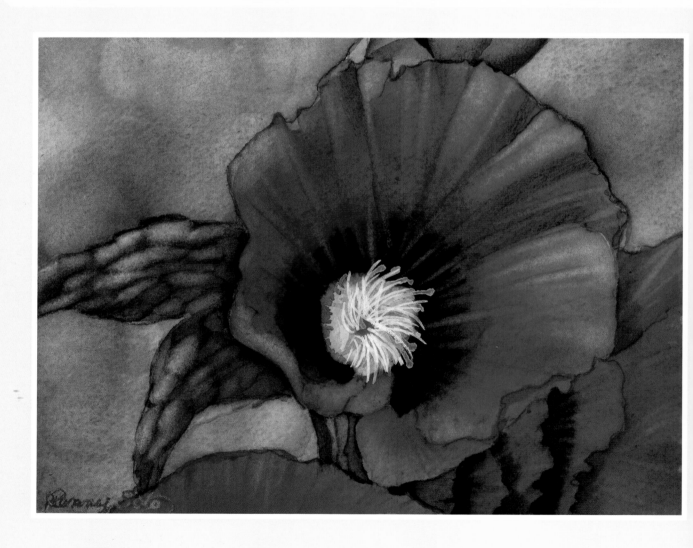

artist's comment

My main objective was to capture the true red/purple colors and the shadows. I started with a 3 value pencil, drawing right on my 300-lb. (640gsm) Arches cold-pressed watercolor paper. Then I erased it slightly, leaving a "ghost image" I could follow.

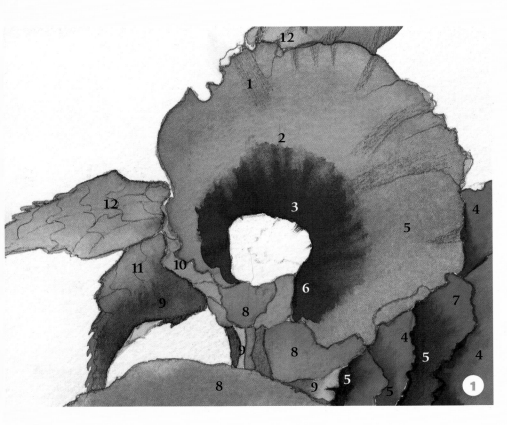

1 Underpaint

Because this painting has a dark flower against a light-to-medium background, you will start with the flower. For your underpainting, let the colors flow together for a smooth effect. Soften the edges on the black part of the middle.

Colors and Mixes

1 Permanent Red + Winsor Violet
2 Cadmium Red Orange
3 French Ultramarine + Indigo
4 Tyrian Rose + Winsor Violet
5 Winsor Violet
6 Winsor Violet + Indigo
7 Permanent Red
8 Tyrian Rose + Permanent Red
9 Permanent Sap Green + Indigo
10 Tyrian Rose
11 Permanent Sap Green
12 Peacock Blue + Sap Green

Hollyhock 2

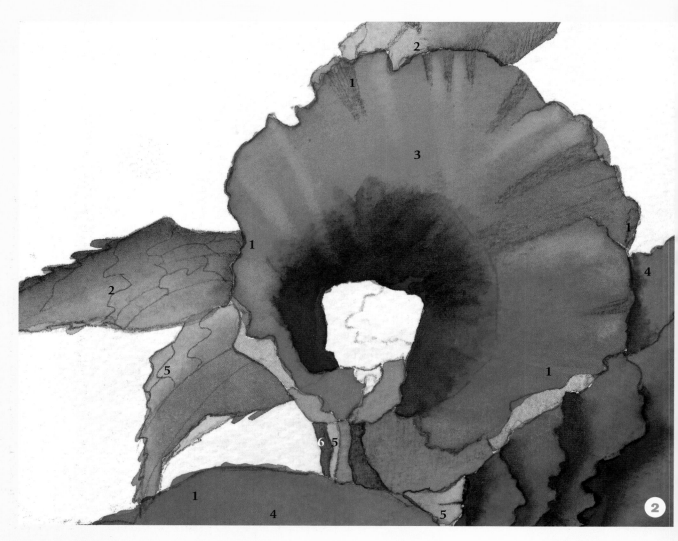

2 Glaze and Glaze and Glaze

Use a soft brush, such as the DaVinci Top Acryl, to glaze the underpainting. Lift out highlights with a flat bristle brush. Use several glazes, drying between each, to slowly bring up the rich dark colors.

Colors and Mixes

1 Tyrian Rose
2 Permanent Sap Green
3 Permanent Red
4 Opera + Permanent Red
5 Thalo Yellow Green
6 Peacock Blue + Permanent Sap Green

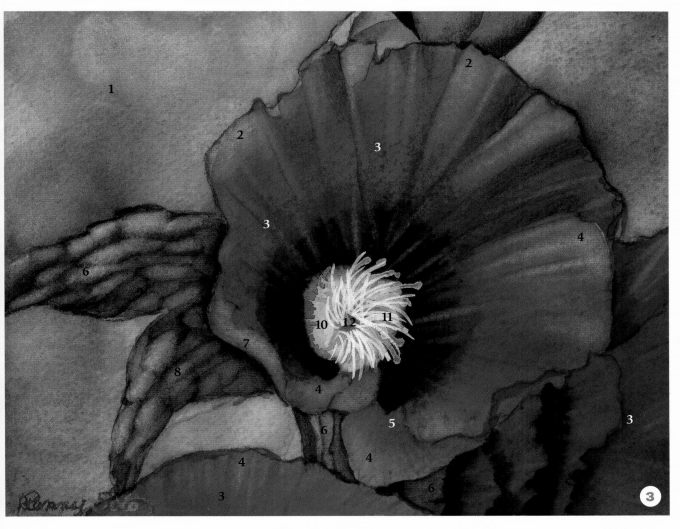

3 Glaze More, Paint Background

Reglaze all colors several times, bringing up the richness. For the background, drop in your colors wet-into-wet. Then lift out the leaves and highlights in the flower. Paint New Gamboge in the middle of the flower and let it dry. Then use Chinese White to make the little lines in the center.

Colors and Mixes

1 Permanent Sap Green + Payne's Gray + Peacock Blue
2 Tyrian Rose + Winsor Violet
3 Permanent Red + Quinacridone Purple
4 Tyrian Rose
5 Permanent Red
6 Sap Green
7 Indigo
8 Peacock Blue + Permanent Sap Green
 9 Permanent Sap Green + New Gamboge
10 New Gamboge
11 Chinese White
12 Alizarin Crimson

Hollyhock 3

BETTY CARR

MEDIUM: *Watercolor*

COLORS: *Alizarin Crimson • Sap Green • Ultramarine Blue • Antwerp Blue • Permanent Rose • Cobalt Blue • Indian Yellow • Burnt Sienna (Color names may vary from brand to brand.)*

BRUSHES: *Round - no. 8, 10 or 12 • Small rigger*

OTHER SUPPLIES: *140-lb. (300gsm) cold-pressed watercolor paper • Pencil • Soap • Grafix Incredible White Mask • Rubber cement pickup*

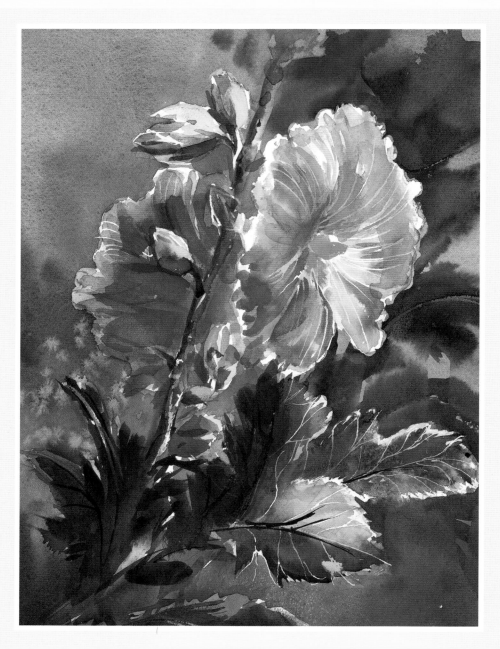

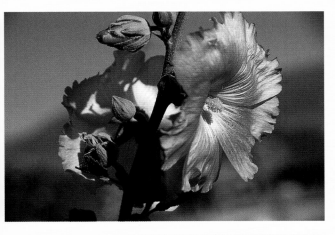

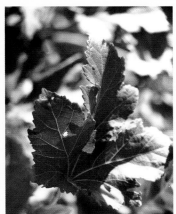

Artist's Reference Photos
These photos taken in bright daylight provide good reference of a hollyhock flower, bud and leaf. Note the veins on the strong arch of the leaf.

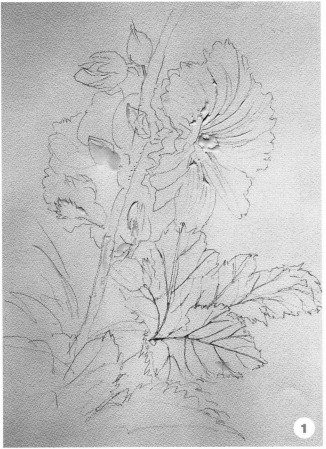

1 Sketch and Mask

Draw a sketch of the hollyhock. Using a small rigger, mask the leaf veins. Soap up the brush hair for protection before dipping into the masking fluid. Note that the leaf's structure and linework conform to the veins. Mask the flower center and veins, taking care to follow the petal arch. Note the flower's funnel shape and the radial direction of the petals. Continue masking details, keeping in mind that the mask is used to protect the lights that will illuminate the flower.

2 Paint Warm Underglaze

After the masking fluid is dry, remove it with a rubber cement pickup and then paint the flower with a light wash of Indian Yellow. Also establish stems and leaves. Use a light wash of Permanent Rose to begin the flower shape.

Hollyhock 3

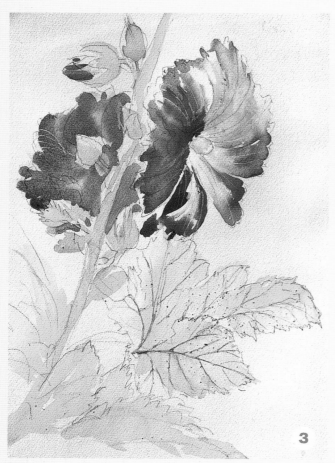

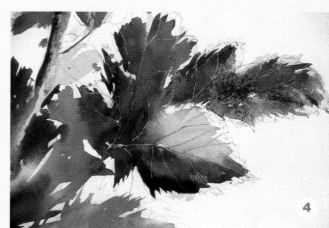

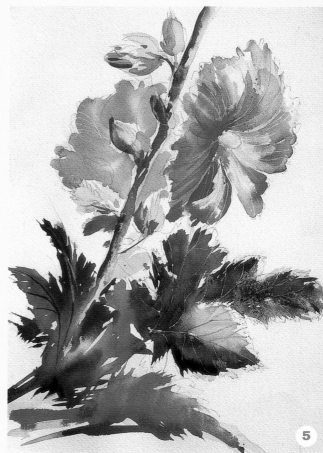

3 Add Color Punch to Flower

Continue charging (adding paint to paint), using Permanent Rose to develop the flower shapes.

4 Add Warm and Cool Colors to Leaves

Using Indian Yellow, Cobalt Blue and Sap Green, mix and allow the warm and cool colors to blend on the paper. Put water down on the leaf first and then drop the colors into the leaf, adding an additional touch of Burnt Sienna in the dark areas. Allow the paint to mix on the paper, rather than overmixing on the palette.

5 Stand Back and Look

Here you see the nice diagonal direction of the majestic hollyhock.

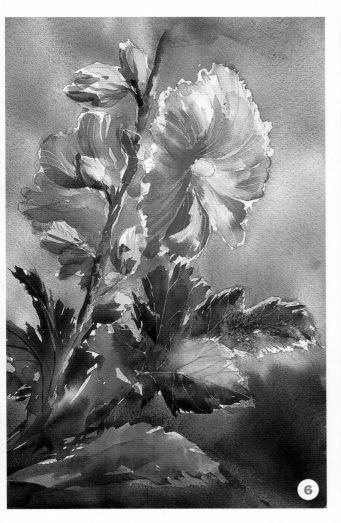

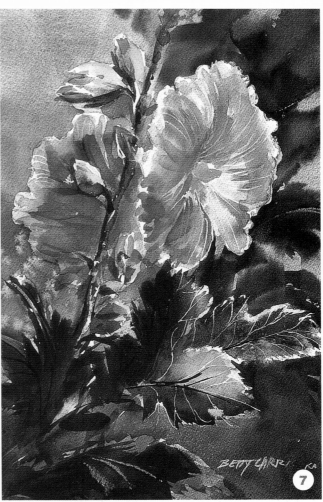

6 Drop In Background

Wet the entire surface area around the flower and drop in Ultramarine Blue at the top, Cobalt Blue in the middle and Antwerp Blue and Burnt Sienna in the lower portion. Allow the paint to move around for soft transitions. Note how the luminosity of the light, with the help of the contrasting background, describes the flower shape. Also note how the blurred edges of the green lower background add a nice contrast to the hard edges of the flower.

7 Add Finishing Touches

Let dry and then rewet the background. Drop Alizarin Crimson, Antwerp Blue and Burnt Sienna on the background around the large flower shape to suggest distant hollyhocks. This will contrast nicely with the hollyhock, staging the light on the flower shape.

Iris 1

SANDY KINNAMON

MEDIUM: *Watercolor*

COLORS: **Winsor & Newton Artists' Water Colours:** *New Gamboge • Rose Madder Genuine • Winsor Red • Cobalt Blue • Winsor Blue • Winsor Green*

BRUSHES: **Loew-Cornell:** *Wash, series 7150 - ½-inch (13mm) & 1-inch (25mm) • Round, series 8000 - nos. 4 & 8*

OTHER SUPPLIES: *140-lb (300gsm) cold-pressed watercolor paper • Old round for masking • 2B pencil • Kneaded eraser • Masking fluid • Rubber cement pickup (optional) • Spray bottle • 2-3 pieces of plastic wrap (enough to cover painting) • Small piece of sponge • Single-edge razor blade*

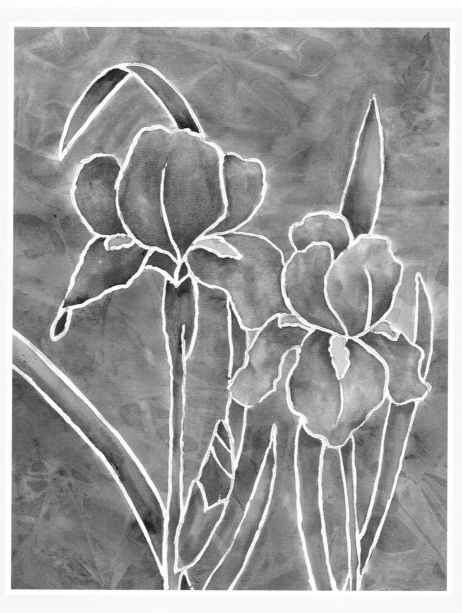

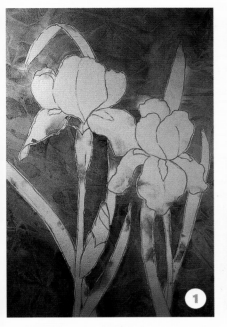

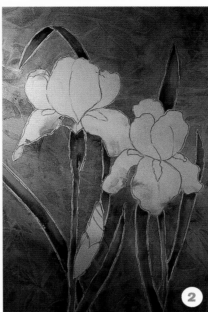

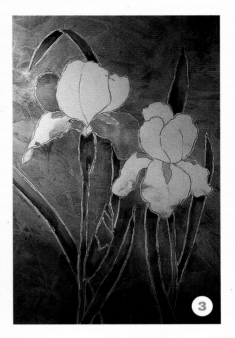

artist's comment

Think of this painting as stained glass. Outline each petal and leaf with liquid mask. When the mask is removed, the unpainted outlines represent the metal strips between the glass pieces. Fresh paint gives you vibrant colors.

1 Mask Outlines, Paint Background

Sketch the flower. Mask just outside the outlines of all leaves, stems and petals with a consistent width of masking. Let this dry naturally.

Wet the whole painting with clean water. Quickly place fresh Winsor Blue and Winsor Green (more blue) outside the masked outlines, letting the colors run together. About halfway through, cover the painted area with plastic wrap. Continue painting and covering, rewetting the surface if necessary. Let dry completely and then remove the plastic. Blue paint smears on flowers can be left. Green can be lifted with a damp sponge. Replace masking, if necessary.

2 Paint Leaves and Stems

Using fresh paint, mix Winsor Green + New Gamboge. To one portion of this, add a tad of Winsor Red. To another portion add more New Gamboge. Float these three greens on the leaves and stems, wet into wet, starting with the lightest green.

3 Paint Petals

Using fresh paint, mix Rose Madder Genuine and Cobalt Blue. Float this purple, wet-into-wet, on the petals. Wait a minute and then drop in some Rose Madder Genuine or some Cobalt Blue, letting the paint blend. Near the base of the petals or where the petals turn, drop in darker values. Let the paint dry.

4 Apply Finishing Touches

(See completed painting on opposite page.) Remove the masking with a clean finger or a rubber cement pick up. If you missed an area of background, paint it now. If areas of paint dried light, wet those areas again and drop in more paint. If your white outlines are thin or uneven, make corrections by scratching out paint with a razor blade.

Iris 2

MARY SPIRES

MEDIUM: *Watercolor*

COLORS: **Daler-Rowney Artists' Water Colour:** *Burnt Sienna • French Ultramarine Blue • Gamboge • Quinacridone Magenta • Indigo*

BRUSHES: **Robert Simmons by Daler-Rowney:** *Sienna skyscraper flat - 1-inch (25mm) • Sienna round - no. 8 • Sienna script - no. 4*

OTHER SUPPLIES: *140-lb. (300gsm) watercolor paper • Masking fluid*

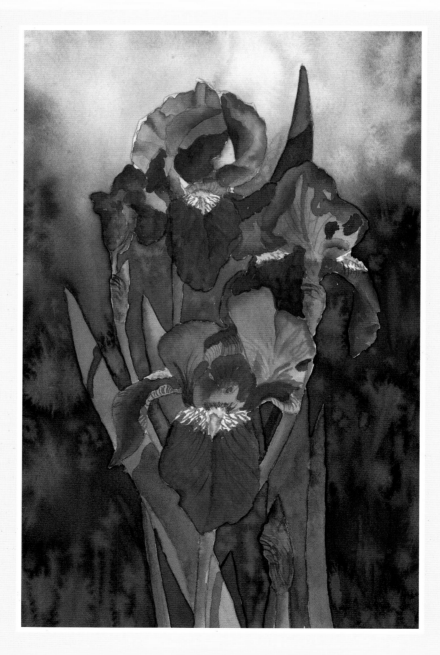

1 Mask, Tint and Glaze

Sketch the irises. Apply masking fluid on the beards and below the beards. Let the mask dry and then saturate the paper with water. Use the skyscraper to drop in light values of Red Violet and Blue Green. Tilt the paper and let the colors blend.

With a no. 8 round, glaze with Red Violet on the petals and Yellow Green on the stems and leaves. Layer the paint to get the desired values.

2 Develop Buds

Buds are Burnt Sienna with a touch of Blue Violet blending into each other and layered. Paint the veins with a no. 4 script and Blue Violet.

3 Create Petal Folds and Turns

Paint V-shaped petal folds with Blue Violet. Soften the edges with a damp brush. Create turned petals by wetting the area with water and then applying the paint at the fold's edge, where the value is darker. Let this bleed toward the outer edge of the petal.

4 Define Shapes

Further define shapes by dropping Red Violet and Blue Violet onto wet petal areas and letting the colors blend. Leaves are also painted wet-into-wet, with Yellow Green.

5 Add Layers, Finishing Touches and Background

(See completed painting on opposite page.) Continue adding layers until you get the desired values. Then remove the mask and paint the beards Gamboge with a touch of Burnt Sienna. Paint the petal veins with a no. 4 script and Blue Violet.

Wet the background and, starting at the bottom, drop in dark values of Indigo, Blue Green and Blue Violet, letting them bleed. As the paint starts to dry, splatter with clean water to create soft background blossoms.

artist's comment

Color mixes in the directions are identified with the following names:

Yellow Green = Gamboge + French Ultramarine Blue
Blue Green = French Ultramarine Blue + Gamboge
Red Violet = Quinacridone Magenta + French Ultramarine Blue
Blue Violet = French Ultramarine Blue + Quinacridone Magenta

Iris 3

JODIE BUSHMAN

MEDIUM: *Acrylic*

COLORS: **Delta Ceramcoat:** *Burnt Sienna • Lemon Grass • White • Passion • Deep Lilac • Pale Lilac • Crocus Yellow • Light Foliage Green • Medium Foliage Green*

BRUSHES: **Loew-Cornell:** *Filbert, series 4500 - no. 2 • Liner, series 7350C - no. 0 • Angular shader, series 7400 - ¼-inch (6mm)*

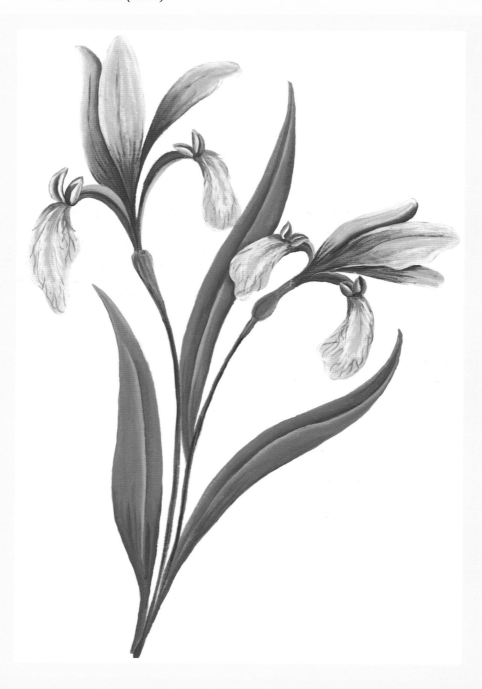

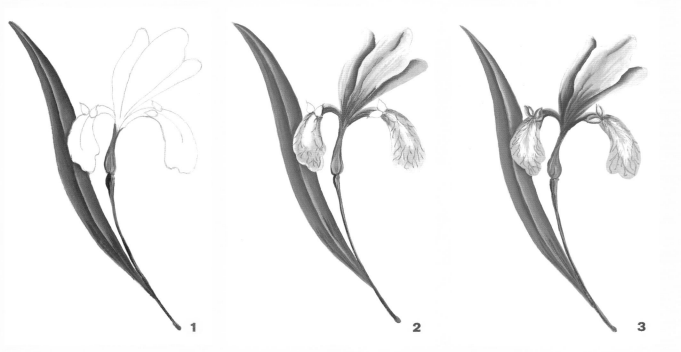

1

2

3

1 Paint Leaves

Base the leaves with Light Foliage Green. Shade leaf centers and backs with Medium Foliage Green. With the same color, pull a few lines up from the leaf bottoms. Highlight the leaf center with a side load of Lemon Grass. The stems are a mix of all greens. Add a bit of Burnt Sienna along the lower stem and where the stem meets the calyx.

2 Paint Petals

Base the petals with Pale Lilac and the filbert. Side load Deep Lilac to shade and separate the petals. Highlight with White. Paint veins on the front petals with thinned Deep Lilac and the liner.

3 Add Details

Paint White down the center of the front petals, feathering the color on the sides. Add Crocus Yellow inside this area and then Burnt Sienna near the throat. Paint the small turned-back petals as you did the large ones. Darken the shading where needed with a side load of Passion.

artist's comment

This wild iris is called a mountain iris. I've seen mountain meadows covered with this flower, creating the effect of a lavender blanket. The three main petals of the bloom symbolize faith, wisdom and courage.

Lilac

MAUREEN MCNAUGHTON

MEDIUM: *Acrylic*

COLORS: **DecoArt Americana:** *Driftwood • Light Buttermilk • Buttermilk • French Vanilla • Pineapple • Moon Yellow • Camel • Antique Rose • Reindeer Moss Green • Dried Basil Green • Light Avocado • Antique Green • Green Mist • Midnite Green* • French Mauve • Mauve • Cranberry Wine* • Raw Umber**

BRUSHES: **Maureen McNaughton:** *Round - nos. 4 & 6 • Philbert - nos. 6 & 8 • liner - no. 1 • Flat no. 8 • Mop - no. 2 • Professional Series 200 - nos. 6 & 10*

OTHER SUPPLIES: *Stylus • Maureen's Extender: distilled water + DecoArt Easy Float (3:1). Add one drop to colors* not *indicated above with an asterisk (*).*

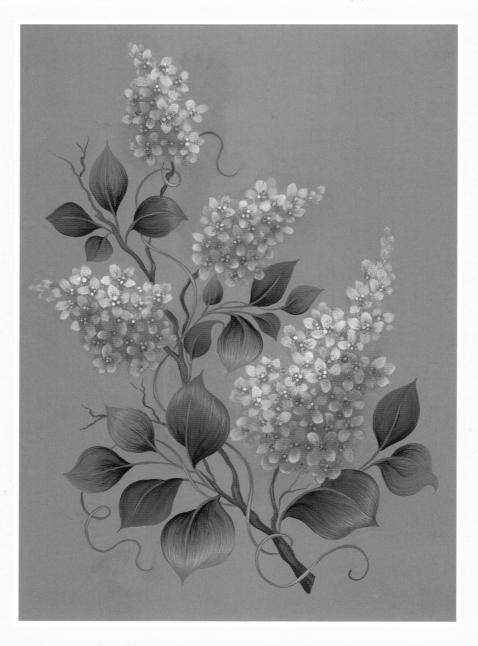

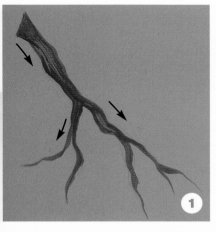
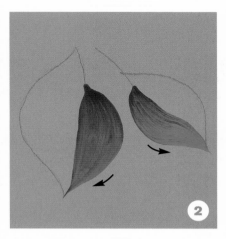
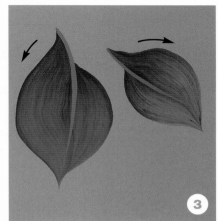

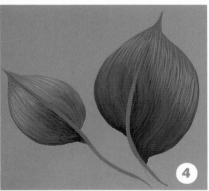
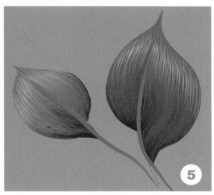

1 Paint Branch
Paint the background with Driftwood and sketch the flower. Load the liner in Raw Umber. Then roll the brush as you pull to create an irregularly shaped branch. Pull lines of brush-mixed Raw Umber + Camel to highlight.

2 Begin Leaf Blades
Using no. 4 and no. 6 rounds, form the short side of the leaves with pointed comma strokes, keeping the inside edge flat. For warm leaves, load in Light Avocado + a touch of Mauve to dull and tip in Midnite Green. For cool leaves, load in Green Mist + a touch of Antique Rose to dull and tip in Midnite Green.

3 Finish Leaf Blades, Pull Veins
Pull the other half of the leaves with two to three strokes each. Pull in the center veins with Mauve.

4 Pull Stems, Highlight
Pull in all leaf stems with Light Avocado + a touch of Mauve, extending into the vein. Create softly rounded highlights across the light end of some leaves with long fine lines. Use Dried Basil Green for the warm leaves; use Green Mist + a touch of Antique Rose + Light Buttermilk for the cool leaves.

5 Brighten Highlights
Brighten the middle third of the highlight with shorter lines of Moon Yellow.

artist's comment

Notice that on the completed painting, some leaves are more yellow and others more blue. In these instructions, the yellow-green leaves are referred to as "warm leaves"; the blue-green leaves are referred to as "cool leaves."

Lilac

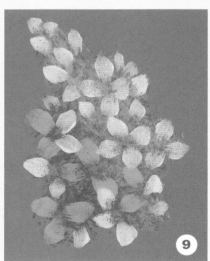

6 Base Lilacs
Using a no. 10 McNaughton Professional Series 200, stipple Dried Basil Green over the entire lilac flowers.

7 Shade Lilacs
Stipple Antique Green in the lower third of each lilac. When the color runs sparse, lightly stipple the rest of the heads.

8 Highlight Lilacs
Stipple Reindeer Moss Green in the upper third of the lilacs. When the color runs sparse, lightly stipple the middles.

9 Form Florets
Using a no. 6 philbert, form individual floret petals with pressure strokes pulled into the center. A full floret has four petals, but most will show fewer. Leave space in the middle of the florets, and allow stipple to show between petals. Use Reindeer Moss Green for petals in the dark areas, with fewer petals toward the middle. Use French Vanilla for mid-value petals throughout the lilacs. Form lightest petals with Buttermilk.

artist's comment

For best results, follow this loading procedure when you stipple the lilacs: Dip the end of the dry brush in color. Pounce out excess paint on a dry paper towel. Apply the color to the lilac evenly with an up-and-down pouncing motion. Before loading a new color, first stroke the brush on a dry paper towel to remove the old color.

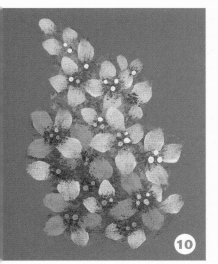

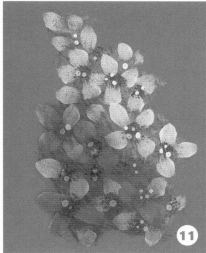

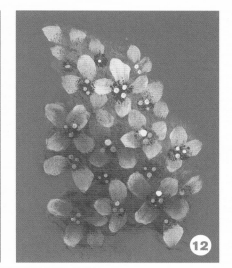

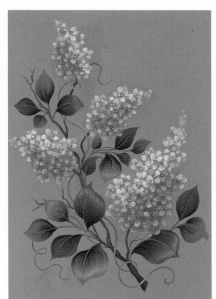

10 Shade and Dot Centers

Using the no. 6 McNaughton Professional Series 200, stipple shading in the middle of the florets and in large open areas to suggest distant florets. Use Mauve in all florets and Cranberry Wine in some of the dark areas.

Dot yellow in the floret centers with a small stylus. Use Camel in florets in the dark area. Use Moon Yellow in the mid-value areas and in some dark and light areas. Use Pineapple in the light areas and some mid-value areas.

11 Glaze Lilacs

Dampen an entire lilac with a large flat and extender. With a no. 8 philbert, quickly brush transparent Cranberry Wine in the lower third of the lilac. Immediately sweep over the area with a dry mop to soften and diffuse the color. Repeat on the rest of the lilacs.

12 Reclaim Petal Tips

Reclaim some petal tips in the glazed area by floating a lighter color with a no. 8 flat. For some use the petal color. For some use the next to lightest color. Use Light Buttermilk on the lightest petals.

13 Pull and Highlight Tendrils

Pull in tendrils with Mauve. Highlight where the tendril crosses over the branch with a long line of French Mauve.

14 Brighten Highlight, Accent Tip

Brighten the middle third of some tendril highlights with a shorter line of Moon Yellow. Shade with a line of Cranberry Wine where the tendrils come out from under a leaf or branch. Also accent the tip of the lower right tendril.

Marigold

KERRY TROUT

MEDIUM: *Acrylic*

COLORS: ***DecoArt Americana:*** *White Wash • Cadmium Yellow • Avocado • Berry Red • Napa Red • Olive Green • Black Plum • Plantation Pine • Black Green • Burnt Sienna*

BRUSHES: ***Loew-Cornell:*** *Round, series 7000 - no. 0 • Flat shader, series 7300 - nos. 4 & 8*

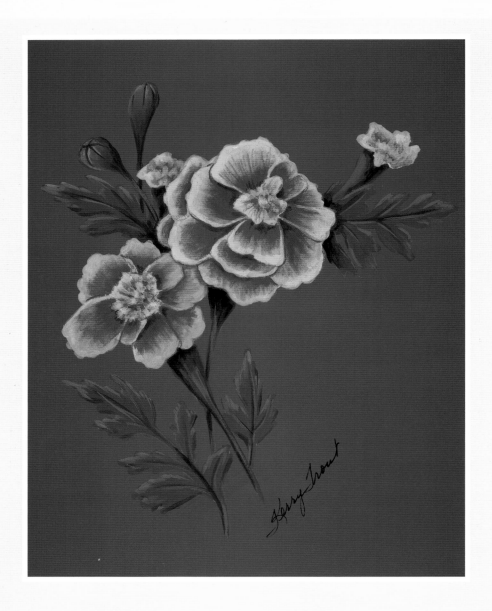

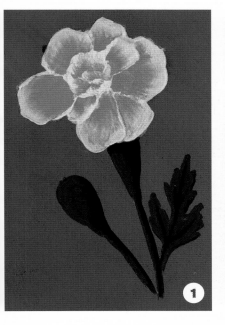

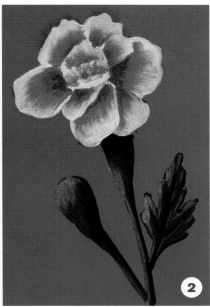

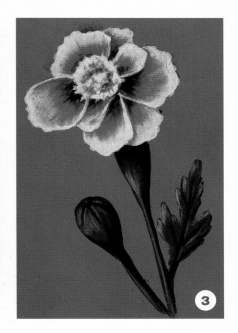

artist's comment

If you're painting this flower on a dark background, such as the blue in my painting, undercoat the blossoms with White Wash. Let this dry before you begin basecoating.

1 Base and Float

Basecoat the blossoms with Cadmium Yellow and a no. 4 flat shader. Base the leaves, buds and stems with Avocado and a no. 0 round. Shade the stems and buds with Plantation Pine. Vein the leaves with the same color.

Load a no. 8 flat shader with Berry Red + Cadmium Yellow (1:2) and float the mix onto each petal, color toward the inside of the flower. For an irregular ruffled effect on the outside of the float, move the brush with a back-and-forth shimmy. Let dry.

2 Float and Highlight

Still using the no. 8 flat shader, float Berry Red onto the first float, making the red float thinner so as not to cover the first float. Use the no. 0 round to apply small strokes of Napa Red onto the base of each petal and where one petal overlaps another. Float Olive Green + Avocado (1:1) along the top of the buds. Then use the no. 0 round to highlight the upper left edges of the stems and leaves.

3 Deepen, Enhance and Detail

Deepen the reddest areas with touches of Black Plum + Napa Red (1:1). Load the round with Cadmium Yellow + a touch of White Wash to enhance the ruffles along the outer edges of the petals and on the inside of the flowers. Deepen shading on the green areas with another application of Plantation Pine. For the deepest shadows, under the flower on the calyx, stroke a touch of Black Green onto the Plantation Pine. Float Burnt Sienna onto the tips of the buds. Then stroke in petal lines with a no. 0 round and Napa Red.

Morning Glory 1

LAURÉ PAILLEX

MEDIUM: *Acrylic*

COLORS: *Blue • Green • White • Yellow*

BRUSHES: *Filbert • Flat • Script liner*

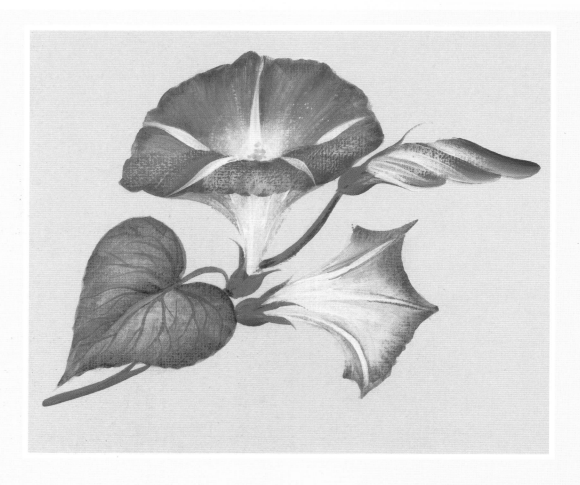

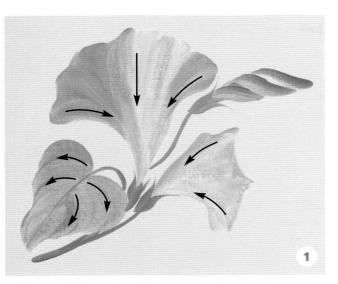

1 Basecoat

Lay in the bud and both flower trumpets with lightly blended filbert strokes. Then place the stems, leaves and calyxes with a script liner double-loaded with two green values. Develop the heart-shaped leaf with multiple filbert strokes, beginning at the center vein and pulling out toward the leaf edge. Start with larger strokes at the stem base and decrease in size as you progress toward the leaf point.

2 Add Petal Lines and Leaf Veins

Pull three long white script liner strokes from the base of each trumpet upward to the outer edge of the crescent. Add fine detail veins to the leaf.

3 Place Flower Edge

Place the front edge of the flower with short filbert strokes.

4 Add Finishing Details

(See completed flower on opposite page.) Highlight the flower center with floated white and strengthen with white "star lines." Add a touch of yellow pollen into the trumpet of the large blossom. Float shading tints around the outside petal edges. Shade the leaves along the center vein and around the outside edges with floated tints of dark green.

artist's comment

Morning glories are found in a vast variety of colors ranging from pale pink to deep blue-violet. When selecting or mixing color values for flowers and leaves, avoid toned hues that appear dull or "grayed." Instead, begin with clean, bright colors and add white or yellow (for leaves) to create lighter values. For dark values and for shading, select a darker color or add a touch of Payne's Gray to the original base color.

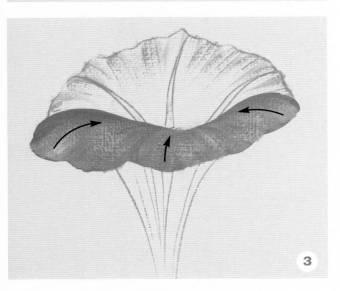

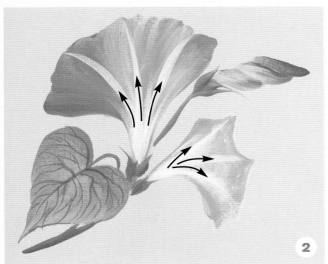

Morning Glory 2

GAYLE LAIBLE

MEDIUM: *Watercolor*

COLORS: ***MaimeriBlu Watercolors:*** *Primary Yellow • Primary Red • Ultramarine Light • Burnt Umber*

BRUSHES: ***Dynasty Watercolor Brushes:*** *Glaze/Wash, Black Gold Series 206FW - ¼-inch (6mm), ½-inch (13mm) • Round, Camelot Series 4000 - nos. 2 & 8*

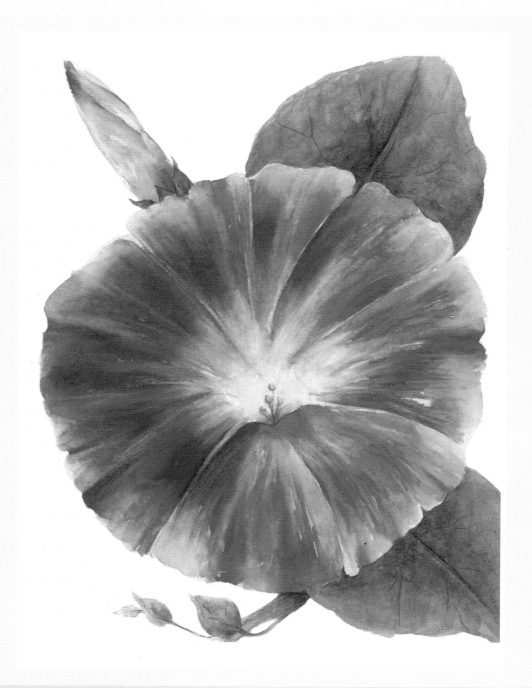

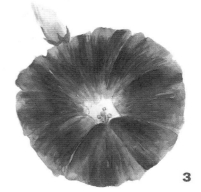

3 Enhance Form

Repeat step 2 to darken. Using Ultramarine Light + Primary Yellow + a touch of Primary Red + Burnt Umber (green) and a no. 2 round, paint the stamen. Then paint a fine green line along a few petal folds. Keep the bud very light, using the same colors.

4 Base and Shade Foliage

Wash over the leaves, stems and calyx with green. Let dry. Darken the large leaf and its calyx where they tuck under the flower. Also darken down the center, along the stem, and at the base of smaller leaves.

5 Add Foliage Details

Darken the green shading with green + blue-violet. Accent leaves, stem and calyx with red-violet. Wipe out the center vein of the big leaves with a damp ¼-inch (6mm) glaze/wash. Pull veins with green + blue-violet. Line the center vein with the same color.

artist's comment

Morning glories don't have multiple petals. The flower is simply full of folds.

1 Wash in Flower

Wash the flower with thinned Ultramarine Light + Primary Red + a touch of Burnt Umber (blue-violet). Wash over the base color with random accents of Primary Red + Ultramarine Light + a tiny touch of Burnt Umber (red-violet).

Paint the center Primary Yellow, softening the outer edge into the flower. When dry, darken the lower area with Primary Yellow + a tiny touch of Primary Red.

2 Add Form

Using a ½-inch (13mm) glaze/wash, shimmy in streaky blue-violet to start establishing the flower form. Touch down at random places on the flower's outer edge.

Pansy 1

ARLENE SWIATEK GILLEN

MEDIUM: *Acrylic*

COLORS: **DecoArt Americana:** *Light Buttermilk • Pansy Lavender • Country Blue • Lilac • Taffy Cream • Pineapple • Blue Violet • Titanium White • Petal Pink • Black Plum • Cadmium Yellow • Avocado*

BRUSHES: **Loew-Cornell:** *Shader, series 7300 - no 10 • Filbert, series 7500 - no. 8 • Long liner, series JS - no. 1 • Liner, series 7350 - no. 10/0 • Round, series 7000C - no. 2*

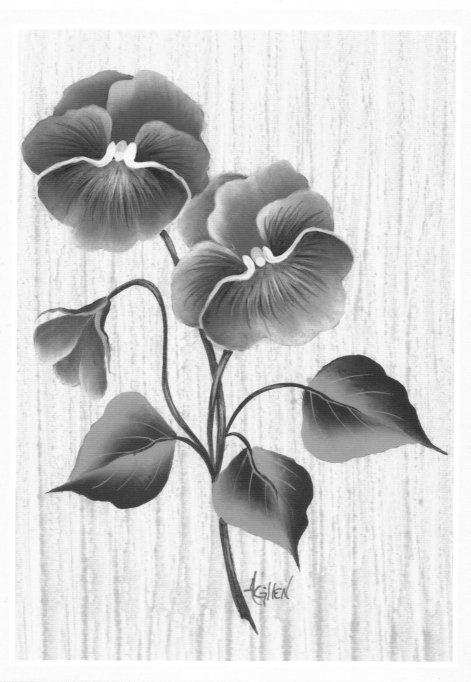

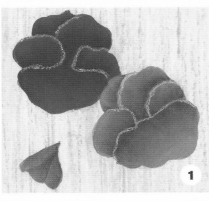

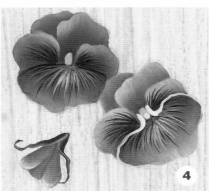

1 Base and Shade Pansies

Base the left pansy with Light Buttermilk + Blue Violet (2:1). Base the right pansy and the bud with Light Buttermilk + Petal Pink + Country Blue (1:1: a touch). Redraw the petal lines. Side load a no. 10 shader in Pansy Lavender and shade the base of each petal. Shade the bud with side-load floats of Pansy Lavender.

2 Highlight Pansies

Throughout this step, use no. 10 shader and side-load floats. Highlight the edges of the blue pansy with Titanium White + Country Blue (5:1). Add more Titanium White to the mix and apply a second highlight. Highlight the edges of the orchid pansy with Lilac and then Light Buttermilk. Highlight the bud with Lilac and then Light Buttermilk.

3 Tint Pansies

Load a no. 8 filbert with Pansy Lavender thinned to a colored-water consistency, blot on a paper towel and apply a sheer tint to the blue pansy. Tint the orchid pansy with thinned Country Blue.

4 Add Pansy Details

Add beards to the side and bottom petals with a no. 10/0 liner and Black Plum. Add Taffy Cream + Cadmium Yellow

(1:1) strokes on the bottom beards. Side load a no. 10 shader and float Black Plum at the top and sides of the bottom petals. With a no. 2 round, paint a Taffy Cream + Cadmium Yellow (1:1) oval between the side petals. Add a dot of Pineapple at the base of the yellow oval. Use the no. 10/0 liner to add a few Taffy Cream strokes to the bottom beards. Paint curved Light Buttermilk lines that start at the oval and continue along the upper edges of the bottom petals. Load the no. 1 long liner in Avocado. Then pull the brush side along the edge of a Taffy Cream + Avocado puddle to pick up a touch of color and paint the bud sepals.

5 Paint Stems and Leaves

Paint stems with a no. 1 long liner and Avocado. Double load a no. 10 shader with Avocado and Taffy Cream + Avocado (3:1) and stroke on the palette to blend. Paint two side-by-side strokes for each leaf, touching the flat side of the brush to the surface, pressing lightly, pivoting and pulling up to the chisel. Reload and blend for each stroke.

6 Pull Veins and Highlight Stems

Use a no. 10/0 liner and Taffy Cream + Avocado (3:1) to add center and side veins on each leaf. Highlight the stems with the same mix.

Pansy 2

M A R G A R E T R O S E M A N

M E D I U M : *Watercolor*

C O L O R S : **Winsor & Newton:** *Winsor Yellow • French Ultramarine*
Holbein: *Indian Yellow • Manganese Blue • Peacock Blue*
Daler-Rowney: *Quinacridone Magenta • Cobalt Blue Deep*

B R U S H E S : *Flat gold sable (synthetic) - ½-inch (13mm) & 1-inch (25mm) • Round gold sable (synthetic) - nos. 5 & 8 • Rigger (synthetic) - no. 4*

O T H E R S U P P L I E S : *140-lb. (300gsm) cold-pressed watercolor paper • HB pencil*

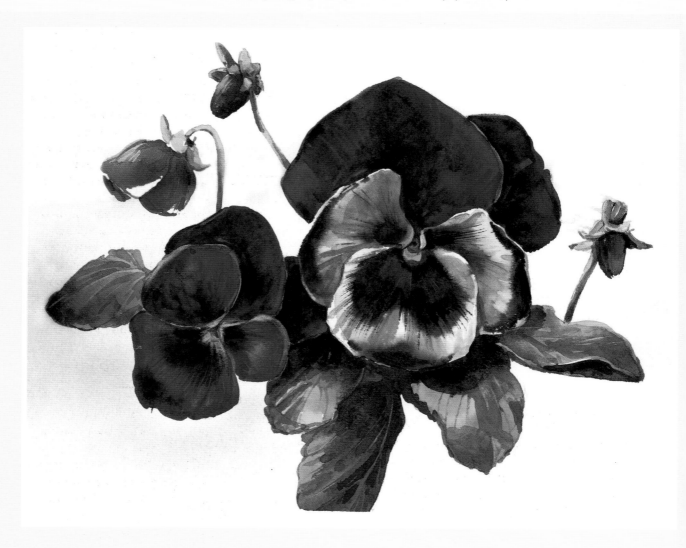

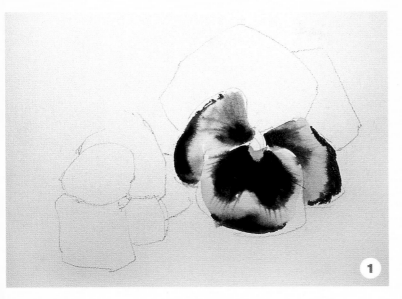

1

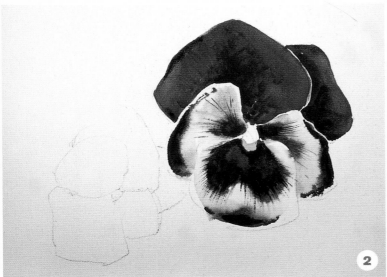

2

artist's comment

A wet-in-wet technique of paint application is ideal for conveying the soft, velvety surface of the pansy. Attention to paint consistency and tremendous self-control in the sequence of color application are key factors in achieving this desired effect.

1 Paint "Face" Petals of Large Pansy

Using an HB pencil, lightly draw the outline of the two pansies. Premix a very dark, concentrated batch of dark blue made up of French Ultramarine Blue + Peacock Blue + Quinacridone Magenta. Do not overmix; you should be able to see the component colors.

Notice the pansy's characteristic five-petal structure. The three bottom petals make up the "face," which has the markings. The outline of those three petals may remind you of Mickey Mouse's head. The two overlapping back petals are a solid color.

Moisten the three "face" petals of the large pansy with water, using a 1-inch (25mm) flat. Using the no. 8 round, paint the small center with medium consistency Indian Yellow. The paint will spread on the wet surface and create a crisp edge in the middle where the paper was left dry. Still using the no. 8 round, apply a light wash of Winsor Yellow in a few areas, followed by a light wash of Manganese Blue, so that these colors are on their own rather than overlapped. Let the paint settle on the paper.

Using the dark blue mix, start painting from the edge of the central yellow area, brushing along the contour of the petal outward. If the paint flows too quickly on the damp surface, wait a little longer before continuing. Apply the dark mix to the inside of the two side petals as well as the outer edges of all three shapes. As the paint settles, use the rigger brush to draw into the middle dark shapes and create the fine contour markings on each petal. A light hand is essential here.

2 Paint Back Petals of Large Pansy

Paint the two large back petals using a varied consistency of Peacock Blue + French Ultramarine Blue + Cobalt Blue Deep + Quinacridone Magenta, leaving white lines between the back and side petals. As the colors fuse, introduce a warm mix of Indian Yellow and Quinacridone Magenta to the edges of the back petals.

Pansy 2

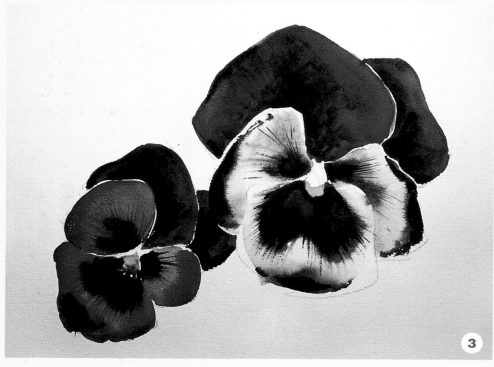

3 Paint Small Pansy
To paint the small pansy, repeat the process used for the large one, but instead of premoistening the three front petals with water, use a wash of Peacock Blue after placing the Indian Yellow for the middle of the flower. As the paint settles, create the markings on the petals, using the dark blue mix. For the edge markings, use a combination of Cobalt Blue Deep + Quinacridone Magenta. Rigger brush detailing, as before, will add more contour information. The two larger back petals are painted as were the larger pansy, again leaving a white line between petals.

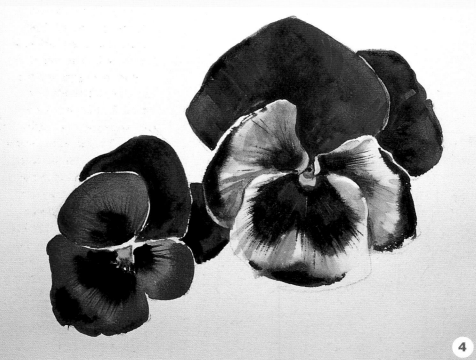

4 Model Large Pansy Petals
Let the paper dry. Use a mix of Cobalt Blue Deep + Manganese Blue to model the "face" petals of the large pansy. Paint a brushstroke of color along the larger front petal as it overlaps the two side petals. Leave the top edge crisp and soften the bottom edges to disperse along the two side petals. This process adds to the three-dimensional effect. A similar treatment is used on the two back petals to suggest an overlapping relationship. Contour these petals by applying a dark blue mix of French Ultramarine and Peacock Blue.

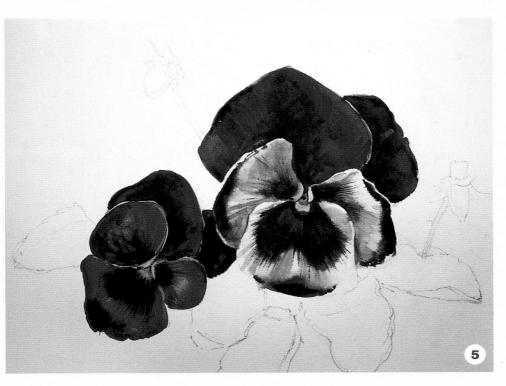

5 Model Small Pansy
Repeat the form-modeling process on the smaller pansy, adjusting for the darker base color. Lightly draw in the shapes of leaves and buds characteristic to the plant.

6 Paint Greenery, Buds, Veins
Using the no. 5 and no. 8 rounds, paint each leaf, starting with a light wash of Winsor Yellow followed by the various greens derived from combining the yellow and blues in this project. Introduce a little warm color made from Indian Yellow + Quinacridone Magenta along the bottom edges of some of the leaves. Use a slightly moistened rigger to create controlled back runs for the vein patterning.

With the rigger and the no. 5 round, model the stems for the buds, using the same greens used for the leaves. The buds themselves are painted with the blues and purples found in the main flowers. Account for the white space between petals by introducing a light wash of Indian Yellow. Lift out fine vein lines on the flowers as well as on some leaves, using the slightly moistened ½-inch (13mm) flat and blotting the painting surface with a tissue. It's easy to get carried away— remember that less is more.

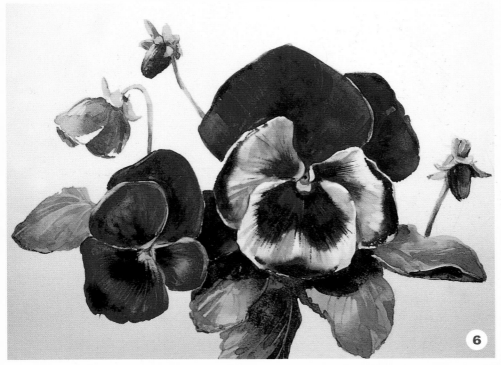

Poinsettia

PAT WEAVER

MEDIUM: *Watercolor*

COLORS: **Daniel Smith:** *Aureolin • Phthalo Green • Cobalt Blue • Winsor Yellow • French Ultramarine* **Holbein:** *Opera • Thalo Green • Cobalt Blue*

BRUSHES: *Round - no. 10 round • Angular flat - 1-inch (25mm) • Rigger - no. 2 (All synthetic sables)*

OTHER SUPPLIES: *140-lb. (300gsm) cold-pressed watercolor paper*

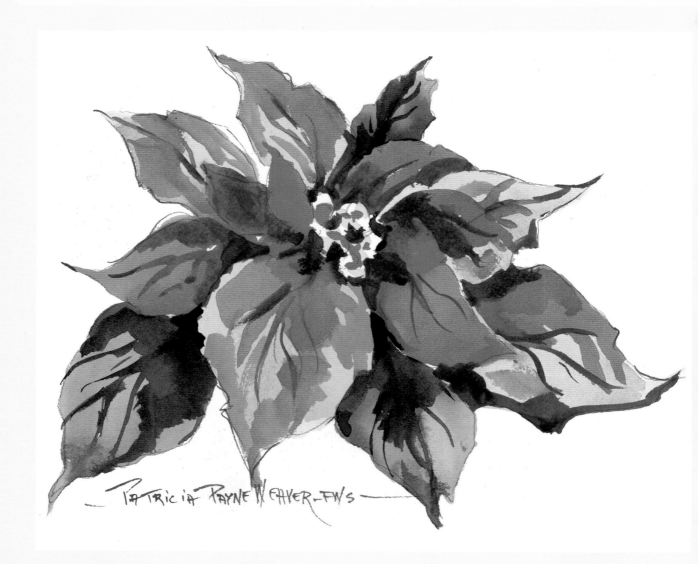

artist's comment

This painting uses many color values, but you can mix them all from only four original colors. The first row below shows those four basic colors. Each of the following rows shows how you can build a color family by adding to your mixes. One of the most important things to remember when painting with transparent watercolor is the ratio of water to pigment. For high key values (very light colors) use more water and less pigment. The darker the value becomes, the more pigment you use in proportion to water. For the very darkest values, use mostly pigment and almost no water.

Original Colors

Aureolin	Opera	Phthalo Green	Cobalt Blue

Color Family 1

Aureolin + Opera + lots of water	Previous mix + Opera	Previous mix + Opera	Previous mix + Opera	Previous mix + Cobalt Blue	Previous mix + Opera + Aureolin added back

Color Family 2

Aureolin + Phthalo Green + lots of water	Previous mix + Phthalo Green	Previous mix + Phthalo Green	Previous mix + Phthalo Green	Previous mix + Phthalo Green	Previous mix + Opera + Cobalt Blue + Aureolin

Color Family 3

Opera + Cobalt Blue + Opera added back + lots of water	Previous mix + Cobalt Blue + Opera added back	Previous mix + Cobalt Blue + Opera added back	Previous mix + Cobalt Blue + Opera added back	Previous mix + Cobalt Blue + Opera added back

Color Family 4

Cobalt Blue + Opera + Cobalt Blue added back + lots of water	Previous mix + Opera + Cobalt Blue added back	Previous mix + Opera + Cobalt Blue added back	Previous mix + Opera + Cobalt Blue added back	Previous mix + Opera + Cobalt Blue added back

Color Family 5

Opera + Phthalo Green	Previous mix + water	Previous mix + water

Poinsettia

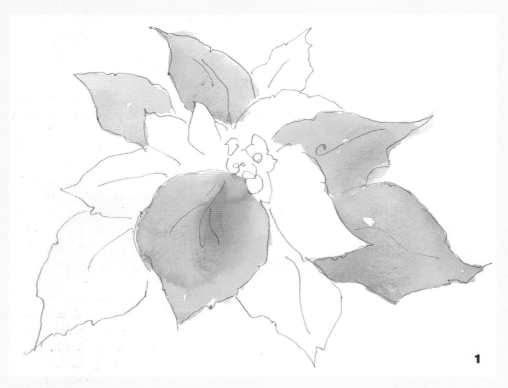

1

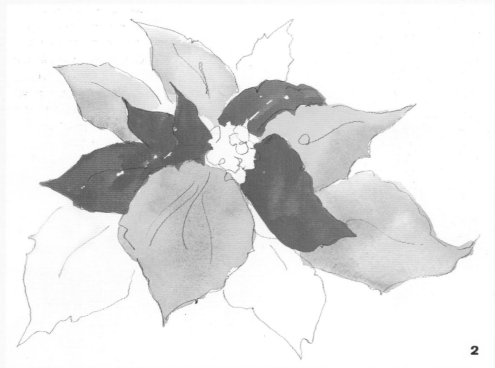

2

1 Apply Lightest Petal Colors

For the first color application, use very "juicy" (mixed with lots of water) Aureolin floated with a very light touch to some petals. While the color is wet, float juicy Opera into the Aureolin.

2 Apply Darker Petal Colors

Mix Aureolin + Opera on the palette to achieve a red much like Cadmium Red Light, but more transparent. Use more pigment and less water to get the darker value. Note that some of the leaves are more pink. For these I used more Opera + Cobalt Blue, producing a red-violet.

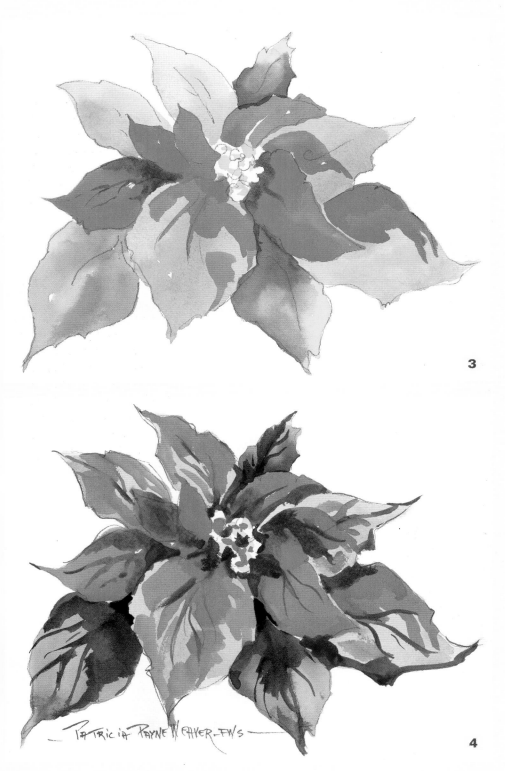

3 Add Darker Values, Leaves, and Center
Go back to previously painted petals and add some darker values and a little more detail. The darkest red is Opera + Cobalt Blue + Opera with not much water. Paint the leaves Aureolin + a little Phthalo Green. While the leaves are wet, float a little orange (Aureolin + Opera) into two. Then add Cobalt Blue + Phthalo Green + water to achieve the cooler, darker green. Apply Aureolin + water into the center of the poinsettia.

4 Add Finishing Touches
Now you're ready to introduce the darkest darks and petal and leaf details. Mix the darkest green with Phthalo Green + Opera, using almost no water.

If you want greens that aren't as bright as the secondary greens, add a little of the complementary color, red, to a yellow-green or yellow-blue mix. This will give you a tertiary green or grayed-down green.

Poppy

BRIGITTE SCHREYER

MEDIUM: *Watercolor*

COLORS: ***Winsor & Newton Artists' Water Colours:*** *Naples Yellow • Permanent Rose • Cobalt Blue • Raw Sienna • Antwerp Blue • Permanent Alizarin Crimson*

BRUSHES: *Flat - 1-inch (25mm) • Round - nos. 3 & 8*

OTHER SUPPLIES: *140-lb (300gsm) cold-pressed watercolor paper • 2H pencil • Hair dryer • Masking fluid*

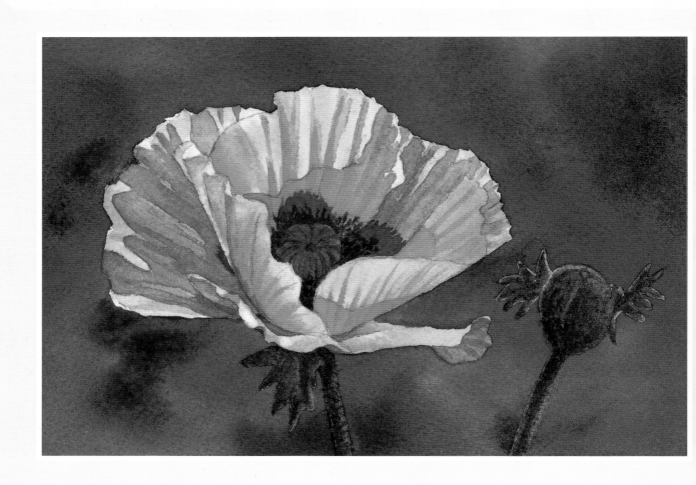

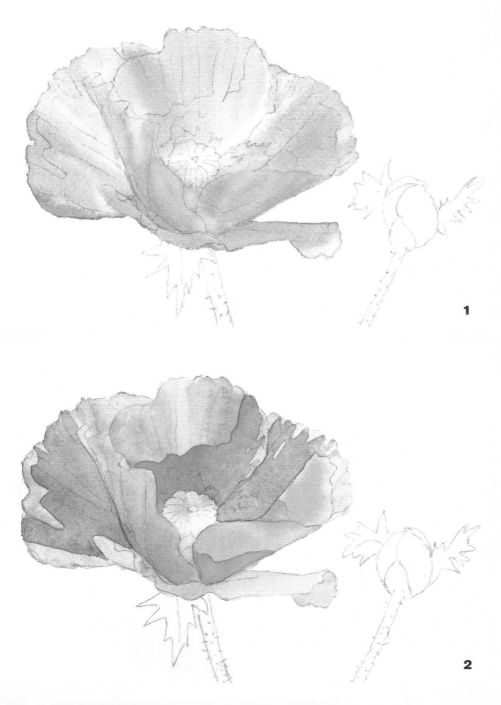

1 Draw and Base Poppy
Draw the flower head, stems, leaves and bud very carefully with a 2H pencil.

Make watery puddles of Naples Yellow, Permanent Rose and Cobalt Blue. Wet the entire flower head with a 1-inch (25mm) flat. Be careful not to go outside the outline of the poppy, or the color you add next will spill into the background.

With a no. 8 round, drop the three pure watery colors into the wet flower. Drop Naples Yellow in the lightest areas, Permanent Rose into the medium areas and Cobalt Blue in the darkest areas (where the shadows might be). Try to keep the middle of the flower light. Dry with a hair dryer.

2 Add Cool and Warm Shadows
Add cool shadows with a light Cobalt Blue. Then mix Naples Yellow + a little Permanent Rose and paint the warm shadows. Drop a little Cobalt Blue into the mix at the right of the upper petal.

artist's comment

Masking the stems, leaves and bud in step 5 makes painting the background easier. Just remember to soap your brush for protection before applying the masking fluid; otherwise you might never use that brush again.

Poppy

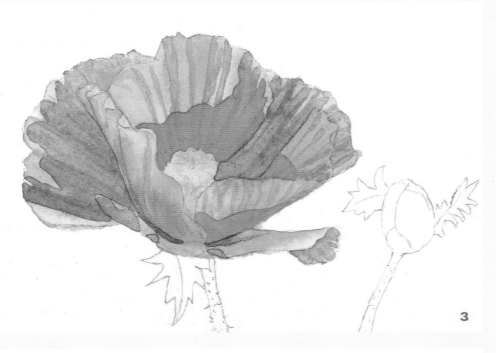

3 Paint Petal Lines
With the point of a no. 8 round, paint fine lines on the petals, simulating a tissue-paper look. Alternate the Naples Yellow + Permanent Rose mix with a thinned-down Cobalt Blue. Let the paint dry.

4 Detail Poppy Center
Mix a small amount of Raw Sienna + a touch of Antwerp Blue and then, with a no. 3 round, paint the radiating green lines in the poppy center. Using the no. 8 round and a light mixture of Permanent Alizarin Crimson and Cobalt Blue, add burgundy to the inside of the poppy and to the poppy center. Darken the same mix with a little more Cobalt Blue and paint the stamens with a no. 3 round.

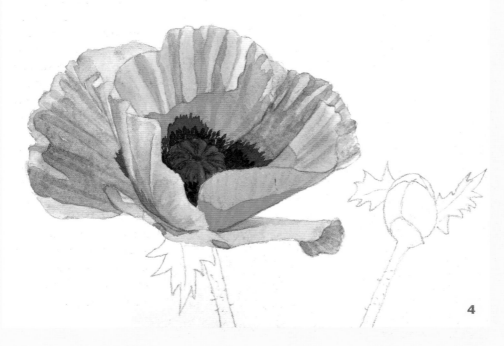

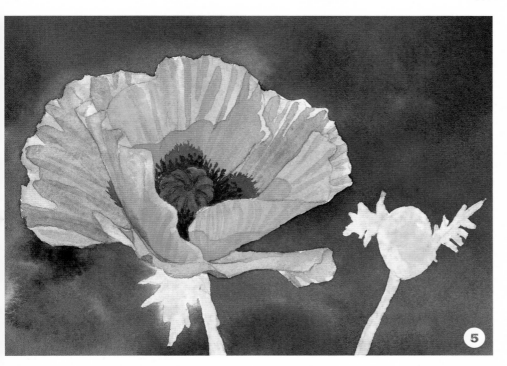

5 Mask, Drop in Background Colors

Mask out the stems, bud and leaves. Let dry. Prepare a Permanent Alizarin Crimson + Cobalt Blue mix as well as puddles of pure Antwerp Blue and pure Cobalt Blue. With a 1-inch (25mm) flat, carefully wet the entire background around the poppy petals and over the masked leaves and bud. Make sure to take off excess water around the edges. With the same brush, drop in the mix and the pure colors separately, letting them blend. Dry with a hair dryer.

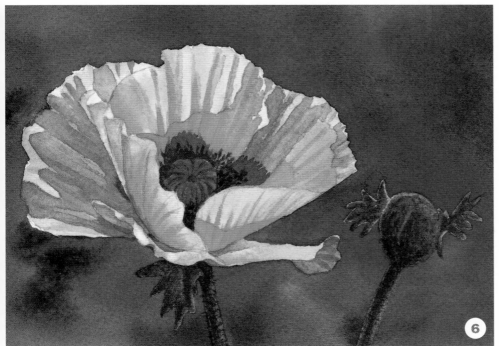

6 Paint Green Elements

Remove the masking fluid. With a no. 3 round and a light mixture of Raw Sienna + a touch of Antwerp Blue, paint the stems, leaves and bud of the poppy. Add more Antwerp Blue to the mixture and, with the same brush, add some darks to make stems, leaves and bud look fuzzy. When dry, add very fine short stubby lines to give a look of hairy stems.

You might want to increase the color values to enhance the tissue-like feeling of the large petals by using colors and brushes as you did in step 3.

Queen Anne's Lace

BRIGITTE SCHREYER

MEDIUM: *Watercolor*

COLORS: **Winsor & Newton Artists' Water Colours:** *French Ultramarine • Burnt Sienna • Raw Sienna • Antwerp Blue • New Gamboge*

BRUSHES: *Flat - 1-inch (25mm) & 1½-inch (38mm) • Round - nos. 3 & 8 • Rigger - no. 2*

OTHER SUPPLIES: *140-lb (300gsm) cold-pressed watercolor paper • 2H pencil • Hair dryer • Masking fluid*

artist's comment

When sketching the Queen Anne's lace, it's especially important to use a 2H pencil. A softer pencil might leave too much graphite on your paper—something to avoid with such a white flower.

1 Paint Background

Sketch a faint outline of the flower with a 2H pencil. On dry paper, mask out the flower heads with a no. 3 round. Don't forget to soap your brush before dipping it into the masking fluid; otherwise you might never use it again.

While letting the mask dry, prepare two somewhat watery mixes. Make one French Ultramarine + a touch of Burnt Sienna, resembling gray sky color for the upper part of the painting. The second is Raw Sienna + a little Antwerp Blue to suggest green grasses in the lower background.

When the masking fluid is dry, wet the entire painting with a 1½-inch (38mm) flat. Wipe away the excess water, and then use a 1-inch (25mm) flat to drop the gray mixture into the top part of the painting, leaving a few white spots. Then paint in the green mixture from the bottom of the painting up. Let the two mixes float together in the middle.

Add more Raw Sienna to the green mix and, with the edge of the 1-inch (25mm) flat, add a few upward strokes in the bottom portion to resemble faint grasses.

Queen Anne's Lace

3 Dab in Flower Clusters
Make sure the paper is completely dry. Then remove the masking fluid. Mix a light wash of French Ultramarine + a touch of Burnt Sienna and use a no. 8 round to apply little dabs to the bottom of every little flower cluster within the Queen Anne's lace head. Note that these dabs run along the bottom edge of the side-view head. Let dry.

4 Enhance Shade and Light Effects
Make sure the first layer of dabbed-on paint is dry. Then add a little more French Ultramarine to the mix. With the tip of a no. 8 round, apply even smaller dabs on top of the first layer, increasing the value. The two values create the semblance of shadow and light within the little flower clusters.

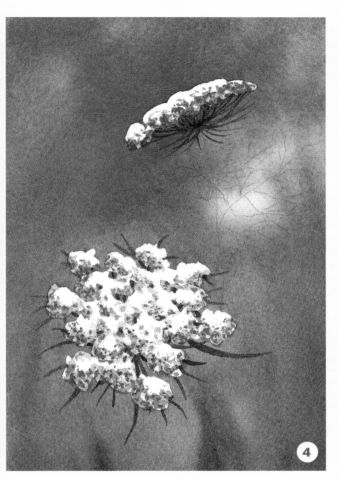

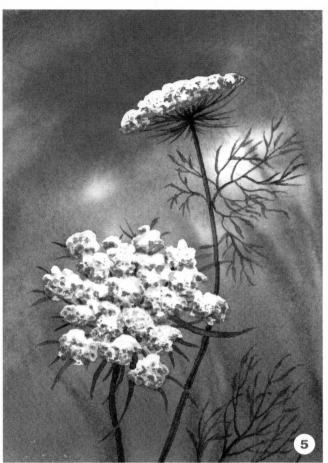

5 Paint Floret Stems

Mix a light wash of New Gamboge + Antwerp Blue and a
darker wash of Raw Sienna + Antwerp Blue. Interchanging
the two color mixes, use the long point of a no. 2 rigger to
paint fine strokes underneath the flower heads. For the full-
face head, stroke from the head outward. For the side-view
head, think of the lines as radiating from a central point
under the head.

 Because of the strong value of the flower heads against the
soft background, the heads appear to be floating. Adding
stems and leaves in the next step will ground them.

6 Finish with Large Stems and Leaves

Using a no. 2 rigger and the Raw Sienna + Antwerp Blue
mixture you used in step 5, paint the flower stems in long
strokes. Then add leaves with a no. 3 round that has a good
point. Add a bit of Burnt Sienna to your mixture and then
paint little shadows on the right side of the stems, increasing
their depth.

Raspberry Blossom

DIANE TRIERWEILER

MEDIUM: *Acrylic*

COLORS: **DecoArt Americana:** *Avocado • Boysenberry Pink • Deep Burgundy • Evergreen • Light Buttermilk • Olive Green • Pineapple • Royal Purple • Titanium White • True Ochre • Violet Haze • Red Violet*

BRUSHES: **Loew-Cornell:** *Angular, series 7400 - ½-inch (13mm) • Flat, series 7300 - no. 4*
Diane Trierweiler's Signature Brushes: *Petal - no. 2 & 8 • Striper - no. 10/0*

OTHER SUPPLIES: *Loew-Cornell Berry Maker*

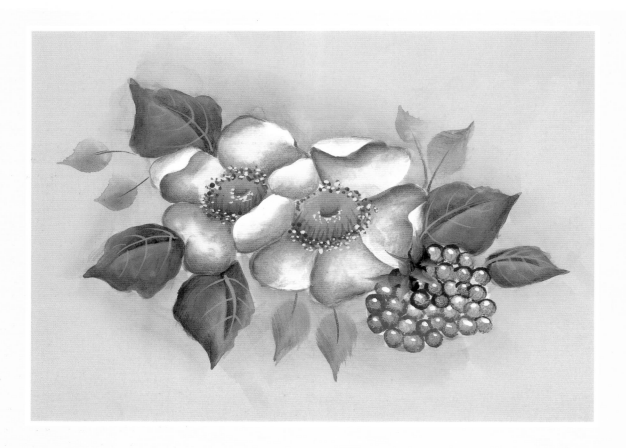

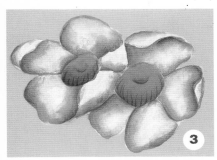

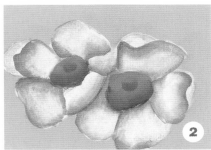

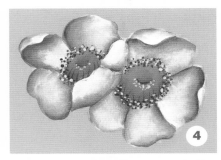

4 Highlight Petal Tips, Dot in Seeds

Corner load the angular with Titanium White and highlight the turned petal tips. Use a 10/0 striper to dot seeds around the centers with Deep Burgundy and then with Pineapple.

5 Dot in the Berry

Dip the berry maker into Red Violet, tap a few times on the palette and then dot the color on half the berry. In the same way, dot Royal Purple on the other half.

6 Finish the Berry

When the berry is dry, wash over it with Red Violet. At the bottom, float in Olive Green with the corner-loaded angular. Add a highlight glint to each berry section with Titanium White on a 10/0 striper. Place the calyx with a double-load of Olive Green and Evergreen on a no. 2 petal brush.

7 Base, Shade and Highlight Leaves

Base the leaves with Avocado on a no. 8 petal brush. Shade with Evergreen corner-loaded on the angular. Highlight with corner-loaded Olive Green.

8 Finish Leaves, Add Filler Leaves and Stems.

Place leaf veins with the striper and Olive Green. Corner load the angular with Deep Burgundy and float a tint onto the leaf tips. With Violet Haze on the no. 8 petal brush, add a backlight onto the dark areas of the leaves. Place filler leaves with watered-down Avocado on the no. 8 petal. Pull Avocado stems with the striper.

1 Base and Shadow Petals

Sketch or trace the flowers. Using a no. 4 flat, base the petals with Light Buttermilk and the flower centers with True Ochre. Lightly replace the petal lines. Corner load a ½-inch (13mm) angular with Boysenberry Pink and float in the first petal shadows. Let dry and then remove petal lines.

2 Enhance Petal Shadows

Float in smaller petal shadows with corner-loaded Deep Burgundy.

3 Tint Petals, Detail Centers

Corner load Royal Purple and tint a few petals. Shade flower centers with Avocado. Then place lines on the flower centers with a 10/0 striper and Deep Burgundy.

Rhododendron

SUSANNA SPANN

MEDIUM: *Watercolor*

COLORS: **Winsor & Newton:** *Indian Yellow • Yellow Ochre • Cadmium Yellow • Burnt Sienna • Rose Doré • Permanent Rose • Permanent Magenta • Winsor Violet • Antwerp Blue • Permanent Sap Green • Payne's Gray*
Holbein: *Cobalt Violet Light*
Daniel Smith: *Cobalt Turquoise*

BRUSHES: **Winsor & Newton Artists' Brushes:** *Series 7 Kolinsky Sable - nos. 1, 2, 3 & 4*

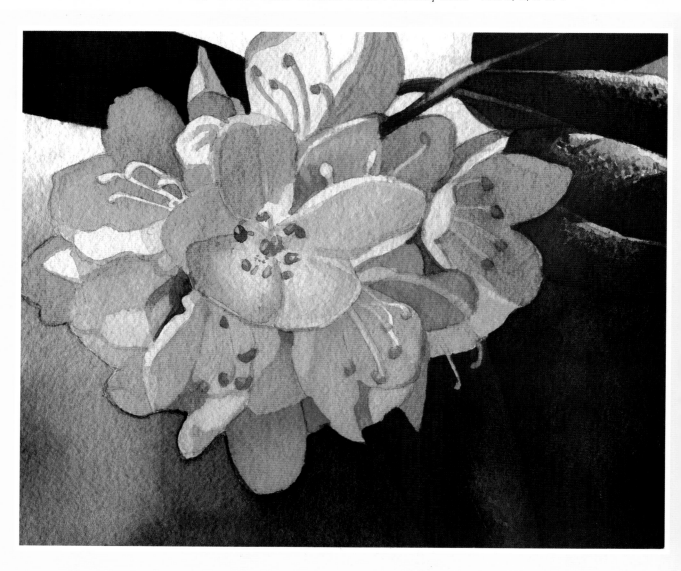

artist's comment

In the instructions for this painting, you'll see references to values 1, 2 , 3, etc., indicating the ever-increasing intensity of color. Value 1 is the white of the paper. The first and lightest paint value is no. 2, followed by no. 3 and so on. As you paint, think in terms of adding a series of value layers.

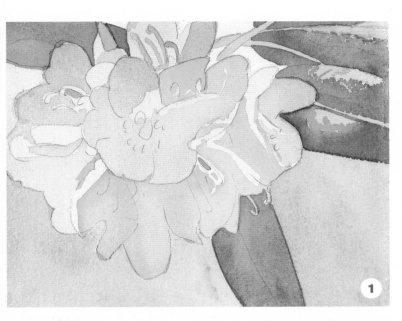

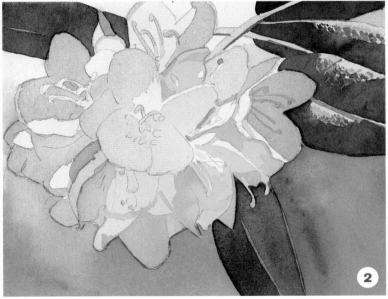

1 Apply Values 2 & 3

Glaze the leaves with value 2 Cadmium Yellow + Indian Yellow, leaving some of the value 1 paper for shine areas. Let dry. Then paint value 2 Cobalt Turquoise in the shine area. Glaze the flower with a value 2 mix of Rose Doré + Yellow Ochre. Glaze the background with value 2 Cobalt Turquoise.

Glaze the leaves with value 3 Permanent Sap Green + Yellow Ochre + Indian Yellow, letting some value 2 of the leaves' shine show through. Glaze the warm flower petals with value 3 Rose Doré + Permanent Rose + Yellow Ochre. Glaze the cool petals with value 3 Rose Doré + Permanent Rose + Cobalt Turquoise. Glaze the background with value 3 Cobalt Turquoise.

2 Apply Values 4 & 5

Glaze the leaves with value 4 Permanent Sap Green + Yellow Ochre + Burnt Sienna, letting some value 2 and 3 show through. In the warm area of the petals, glaze value 4 Rose Doré + Permanent Rose. In the cool area of the petals, glaze value 4 Rose Doré + Permanent Rose + Cobalt Violet Light + Cobalt Turquoise. Glaze the background with value 4 Antwerp Blue + Cobalt Turquoise.

Glaze the leaves with value 5 Permanent Sap Green + Burnt Sienna + Payne's Gray, letting some of the earlier values show. This helps the shine appear and shows the texture and underneath coloring of the leaves. Use a no. 1 brush to stipple. Glaze value 5 Rose Doré + Permanent Rose + Yellow Ochre on the warm petals. Glaze value 5 Rose Doré + Permanent Rose + Cobalt Violet Light + Cobalt Turquoise on the cool petals. Paint the background value 5 Cobalt Turquoise + Antwerp Blue + Payne's Gray. Add clean water to the upper left side, bringing that area back to value 1.

Rhododendron

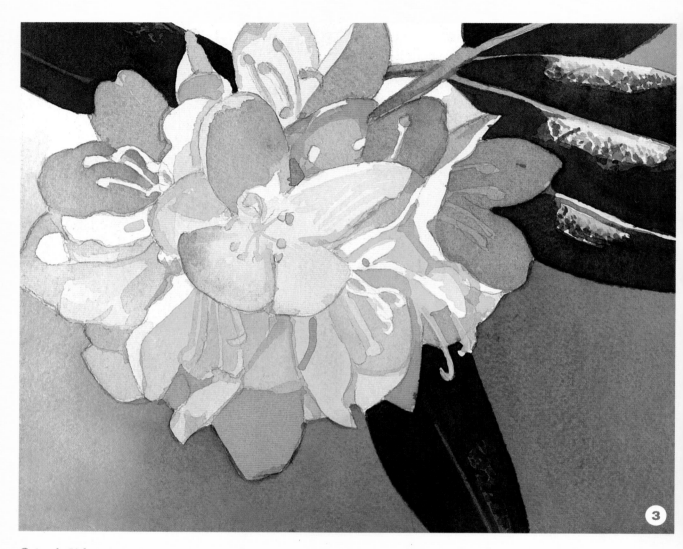

3 Apply Value 6

Glaze value 6 Permanent Sap Green + Burnt Sienna +
Payne's Gray on the leaves, letting the earlier values in the
stipple areas show. Glaze value 6 Rose Doré + Permanent
Rose + Permanent Magenta on the warm petals, letting some
earlier values show through. Glaze the cool petals with value
6 Rose Doré + Permanent Rose + Permanent Magenta +
Cobalt Turquoise + Winsor Violet, again letting some earlier
values show through. On the right of the background, glaze
value 6 Cobalt Turquoise + Antwerp Blue + Payne's Gray.
Also glaze a bit of this mix to the left side of the back-
ground. Apply clean water to the top left, letting it fuse with
the earlier values.

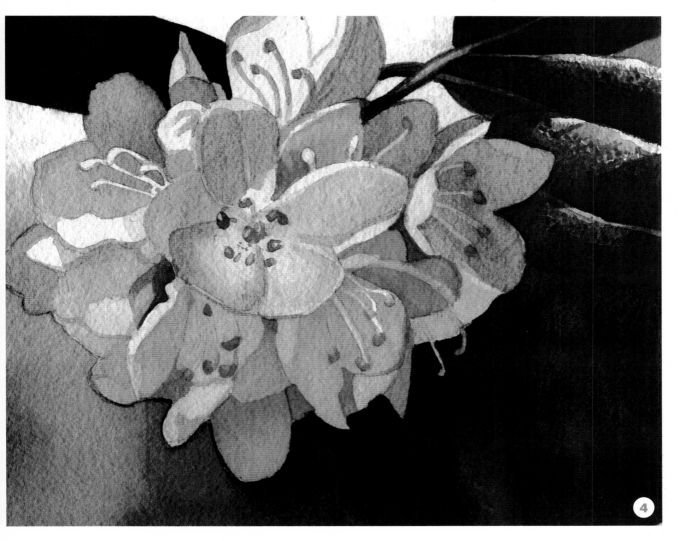

4 Apply Values 7, 8 & 9

Glaze value 7 Permanent Sap Green + Burnt Sienna +
Payne's Gray on the leaves, letting earlier values show. Glaze
the leaf stems with value 7 Burnt Sienna + Yellow Ochre +
Payne's Gray. To add depth to the flower, apply value 7
Burnt Sienna + Winsor Violet in the crevices between some
petals. Paint the anthers with value 7 Yellow Ochre + Burnt
Sienna. Glaze the right side of the background with value 7
Cobalt Turquoise + Antwerp Blue + Payne's Gray. Apply a lit-
tle of this color on the left side of the background. Then add
clear water to this area, letting it fuse into the other values.

Glaze value 8 Permanent Sap Green + Payne's Gray on the
bottom and left leaves. Let dry.

Glaze value 9 Sap Green + Payne's Gray on the top of the
bottom leaf and all over the left leaf. This puts those leaves
in shadow.

Rose 1

LOUISE JACKSON

MEDIUM: *Watercolor*

COLORS: ***Dr. Ph. Martin's Liquid Hydrus Fine Art Watercolor:*** *Hansa Yellow Light • Brilliant Cad Red •*
Deep Red Rose • Cobalt Violet • Ultramarine

BRUSHES: ***Royal & Langnickel:*** *Majestic round (synthetic) - no. 6 & 12 • Majestic flat (synthetic) - no. 20 •*
Soft Scrubber - no. 170 • Stiff scrubber - no. 475

OTHER SUPPLIES: *140-lb (300gsm) cold-pressed watercolor paper, 11" x 15" (28cm x 38cm)*

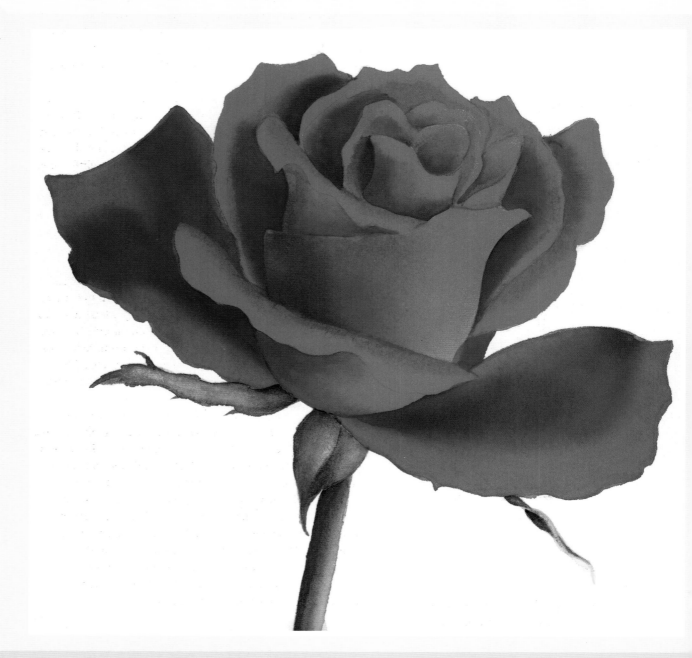

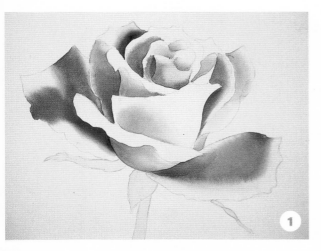

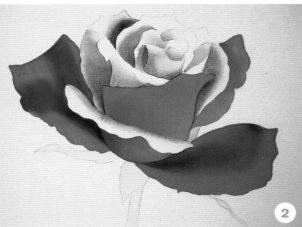

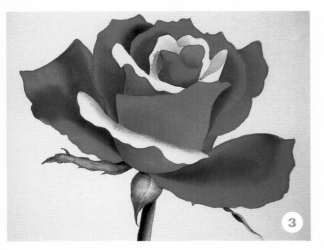

artist's comment

If you choose to paint this rose with tube water-colors rather than liquid, apply many more red layers until you achieve the proper vibrancy.

1 Underpaint the Petals

Underpainting is an easy way to paint in dark areas. First place out about five drops of Cobalt Violet. Wet one petal at a time and apply the paint with a no. 12 round. Rinse the brush, remove the water, flatten the bristles between your fingers, and you'll have a blending brush. Use this to direct the color and soften edges. With a very dry brush, make the Cobalt Violet darker at the bottom of the large petals. Paint a very thin layer of Hansa Yellow Light on the stem and leaves. Dry thoroughly.

2 Add the Local Color

With the dark values in place, you'll only need to add the local color (Deep Red Rose) to some petals. Wet a large bottom petal and paint it with Deep Red Rose on a very dry brush. Prepare the brush for blending as you did in step 1, and pull the color around so it covers the petal. Repeat this process on the other large bottom petal.

All other petals need local color as well as light values. Wet the small petal on the upper right. Apply Brilliant Cad Red to the outside edge and Deep Red Rose to the inside. Wet the large "bowl" in the center, and paint it with Brilliant Cad Red on the right. Use Deep Red Rose for the rest of the bowl. Lightly dampen a soft scrubber. Pull it along the top of the front petal to expose the white paper and soften the hard edge. Wet the bottom of the bowl between the two large petals and apply Brilliant Cad Red to the right and Deep Red Rose to the left.

3 Continue Small Petals, Stem and Sepals

Keeping the paper dry, paint more small petals with Brilliant Cad Red to the outside edge and Deep Red Rose on the inner area. Switch to a smaller brush when necessary. Blend colors as you did before. Make a dark green mix of Ultramarine + Hansa Yellow Light. Wet the stem and apply the mix down the left of the stem. Blend to the right so the color fades. Apply a little Hansa Yellow Light on the sepals. Shade with dark green mix.

4 Complete Petals and Sepals, Add Finishing Touches

(See completed painting on opposite page.) Complete the inner petals with lighter red to the top and darker red in the recesses. Paint petals that curl forward with Deep Red Rose to the top and Brilliant Cad Red to the outside edges. To shade the large sepal, wet only the right half and apply dark green mix down the center. Blend to soften. If you've lost dark values, rewet petal by petal and apply more dark. Let dry. Then rewet and repaint with Deep Red Rose. Remove any background paint smudges with a stiff scrubber or toothbrush and water. If you want background color, you'll find that black with some green and blue works well against the strong red.

Rose 2

DONNA DEWBERRY

MEDIUM: *Acrylic*

COLORS: **Plaid FolkArt Acrylics:** *Thicket • Wicker White*
Plaid FolkArt Artists' Pigments: *Yellow Light • Yellow Ochre*

BRUSHES: **Plaid FolkArt One Stroke Brushes:** *Flat - nos. 2 & 12, ¾-inch (19mm) • Script liner - no. 2*

OTHER SUPPLIES: *Plaid FolkArt Floating Medium*

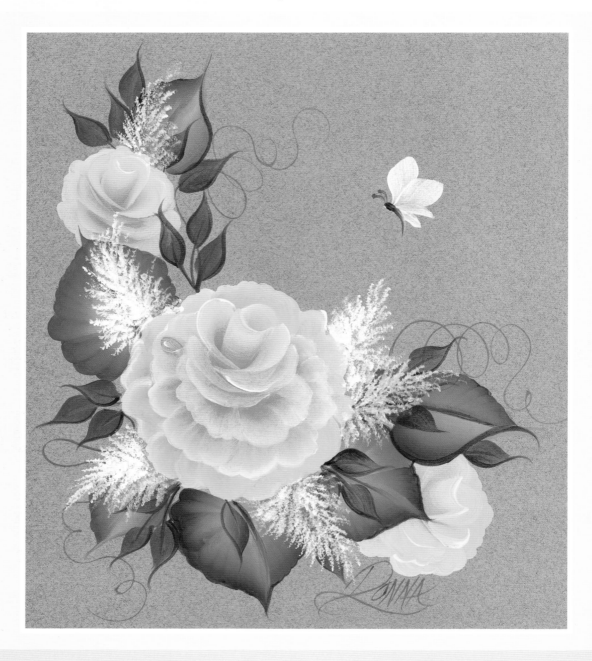

1

2

3

artist's worksheet

Refer to this worksheet for a more detailed look at the strokes and for practice.

Shell Stroke

First "U" Stroke for Bud

Second "U" Stroke for Bud

Chisel Strokes

1 Paint the Rose "Skirt"
Double load a ¾-inch (19mm) flat with Yellow Ochre and Yellow Light. Using the flat side of the brush and keeping the Yellow Light to the outer edge, paint a shell stroke (see the above worksheet). To do so, touch on the chisel edge, lay the flat side of the bristles down and then wiggle out and in while pivoting the Yellow Light around the Yellow Ochre. Connect a second shell stroke to the first by overlapping the outer edges. Add three to four shell strokes to make a circle.

2 Add the Center "Bud"
Paint a "bud" in the center of the rose by touching on the chisel edge with the Yellow Light up and painting a right-side-up "U" stroke. Then paint an upside down "U" stoke (see above worksheet). Then paint a shell stroke on each side of the bud.

3 Finish the Roses
Add three more shell strokes at the base of the bud. Then paint chisel strokes (see the above worksheet) to fill in the center of the rose. Use the chisel edge of the brush with light pressure. Paint the two smaller roses following the same procedure used for the large rose. You need only paint the portions not covered by leaves.

Rose 2

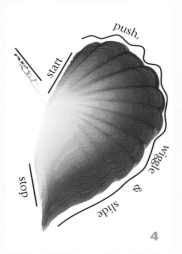

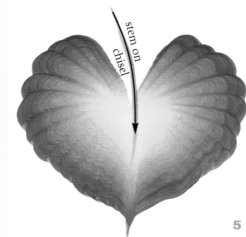

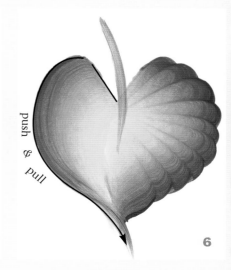

4

5

6

7

Outline Detail

4 Begin Wiggle-Shaped Leaves

For the wiggle-shaped leaves, double load a ¾-inch (19mm) flat with Thicket and Yellow Light. Add a touch of Wicker White to the chisel edge and blend well to soften the colors. Touch on the chisel edge of the brush to form a "V" that points in the same direction as the leaf tip. This "V" is where the leaf connects to the stem. Using the flat side of the brush and keeping Thicket to the outer leaf edge, touch the chisel edge of the brush on one side of the "V," lay the bristles down and wiggle out and in as you pivot the Thicket around the Yellow Light until you see a shell stroke. Then slowly lift to the chisel edge as you continue to turn the Thicket around, finally sliding to make a tip.

5 Finish Wiggle-Shaped Leaves

You can paint the second half leaves as you did the first, or you can use the sliding technique described in the next step. As soon as you finish stroking the second leaf half, pull a stem with the chisel edge, leading with the Yellow Light side.

6 Finish Leaves with Sliding Technique

To paint the second leaf half with the sliding technique, touch the chisel edge on the second half of the "V," with Thicket to the outer edge. Lay the bristles down and then slide as you lift back up to the chisel. Keep your eye on the inner edge to make sure you connect the centers. Don't turn the brush; allow the Yellow Light to reach the tip first.

7 Paint One-Stroke Leaves

For one-stroke leaves, double load a no. 12 flat with Thicket and Yellow Light. Add a touch of Wicker White to the chisel edge and blend well to soften the colors. Using the flat side of the brush, touch on the chisel edge, push down and then slide as you lift to the chisel. Pull a stem into each leaf as soon as you finish painting it. Then load a no. 2 script liner with ink-like consistency Thicket and outline one side of the one-stroke leaf. (see outline detail).

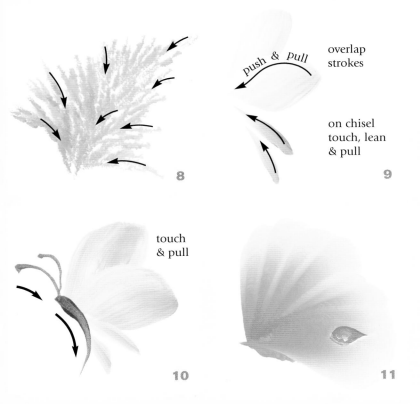

overlap strokes

push & Pull

on chisel touch, lean & pull

8

9

touch & pull

10

11

8 Pounce In Filler Flowers

To paint the filler flowers, load a no. 12 flat with Wicker White. (The flowers here are yellow in order to make them more visible.) Using the chisel edge of the brush and a very light pouncing motion, tap out the flower, keeping it light and airy.

9 Paint Butterfly Wings

For the butterfly wings, load a no. 12 flat with Wicker White. (For this demonstration, I've added yellow to make the wings visible.) Using the flat side of the brush, paint two one-stroke leaves that overlap and connect at the tips. Pull two chisel-edge strokes that connect at the same place.

10 Paint Butterfly Body and Antennae

To make the butterfly body, load a no. 2 script liner with ink-like consistency Thicket. Touch on the tip of the brush at the head area, apply pressure and then slide as you ease the pressure. Add two antennae, using very little pressure.

11 Finish with a Dew Drop

For the dew drop, load a no. 2 flat with Yellow Ochre. Paint a one-stroke leaf shape on a petal of the large rose. Load a no. 2 script liner with ink-like consistency Wicker White. Add a highlight and outline one side of the drop to make a reflection.

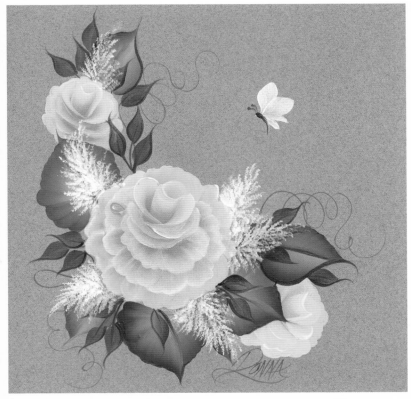

Sweet Pea

SHARON HAMILTON

MEDIUM: *Acrylic*

COLORS: **DecoArt JansenArt Traditions:** *Blue Grey • Carbon Black • Hansa Yellow • Naphthol Red • Pine Green • Quinacridone Violet • Raw Umber • Red Violet • Sapphire Blue • Warm White*

BRUSHES: **Loew-Cornell:** *Comfort shader, series 3300 - nos. 2, 4, 10, 12 & 14 • Comfort wash, series 3550 - 1-inch (25mm) • Liner, series JS - nos. 10/1 & 1*

OTHER SUPPLIES: *Multisurface sealer • Glazing medium • Extender & blending medium*

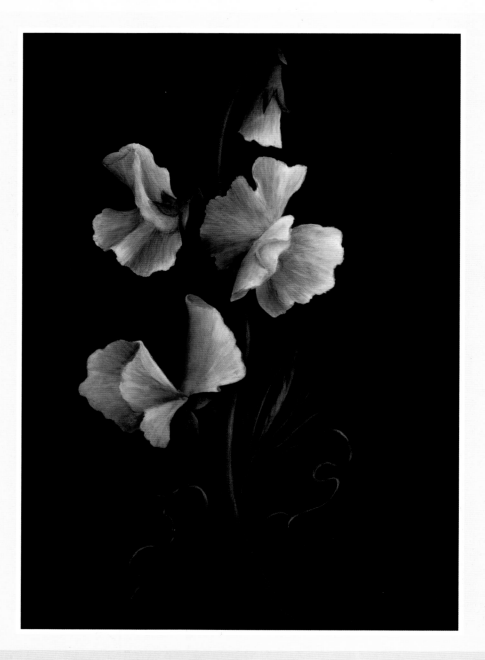

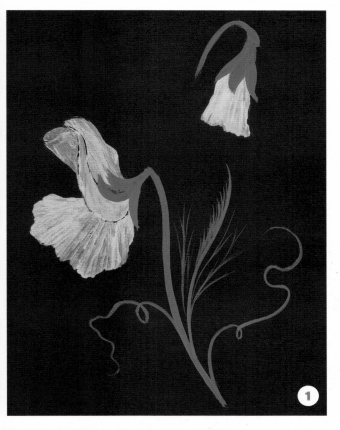

artist's comment

For beautifully soft floats, palette-blend the paint into the brush. Tip the brush corner in the desired paint and then work the brush, lifting it up and down on a small area of a waxed palette. Then flip the brush over and work the loaded side up and down on the same palette area. Use the largest brush that fits in the area you're floating.

1 Base

For a black background, mix Carbon Black + Blue Grey (1:1) and then mix this with an equal part of sealer. Basecoat the background with a 1-inch (25mm) wash.

Basecoat the stems, calyxes, leaf and vines with a no. 1 liner loaded with Pine Green + Warm White + Quinacridone Violet + Hansa Yellow + Red Violet (5:2:1:1:½). Base the petals with Warm White + Napthol Red (10:1), using a no. 10 shader.

2 Add Dark Floats to Green Elements

Side load Pine Green + Warm White + Quinacridone Violet (5:1:1) onto a no. 4 shader and float it along the left edge of the stems, calyxes, leaf and vines. Side load Pine Green + Quinacridone Violet + Raw Umber (3:1:1) onto a no. 2 shader and repeat the floats within the established dark areas.

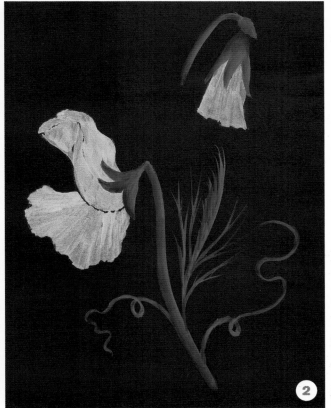

Sweet Pea

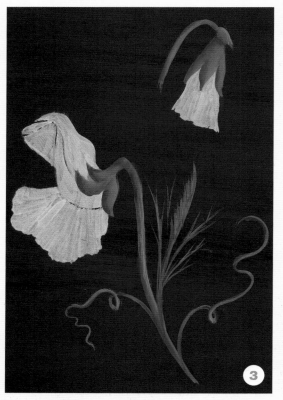

3 Add Highlights and Tints to Green Elements

Side load the first mix (Pine Green + Warm White + Quinacridone Violet + Hansa Yellow + Red Violet [5:2:1:1:½]) + Warm White + Hansa Yellow (3:1:1) onto a no. 2 shader. Float the mix along the right edge of the stems, leaf, calyxes and vines. Load a no. 10/0 liner with Hansa Yellow + Warm White (1:2) and build up the light areas with dry-brushing. Side load thinned Quinacridone Violet onto a no. 2 shader and float tints within the dark areas of the stems, calyxes, leaf and vines.

4 Add Darker Floats to Petals

Side load a no. 14 shader with Warm White + Napthol Red + Quinacridone Violet (8:2:1) and walk a float from the base of each petal and within the recessed area of each ripple. Side load Warm White + Napthol Red + Quinacridone Violet (1:1:1) onto a no. 10 shader and deepen the previous floats.

5 Add Lighter Floats to Petals

Side load Warm White + Napthol Red (18:1) onto a no. 12 shader and use the chisel edge of the brush to walk a float along the light edges of the petals. Side load Warm White onto a no. 10 shader and lighten the previous floats. Apply a thin layer of glazing medium with a no. 14 shader and allow it to dry.

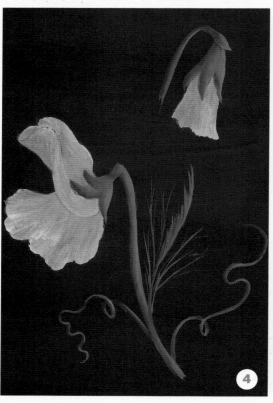

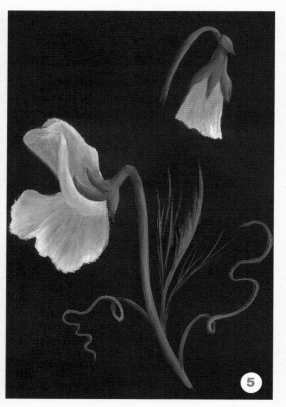

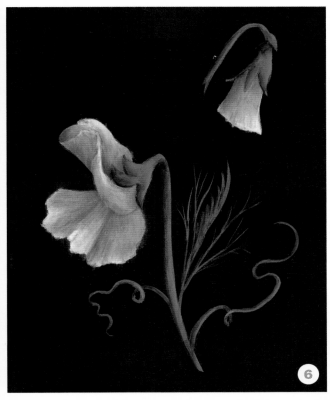

6 Add Darkest Petal Floats and Tints

Dress a no. 12 shader with extender and side load the background mix (Carbon Black + Blue Grey + sealer [1:1: 2]). Float the mix in the deepest shadow areas of the petals. Load a no. 10 shader with extender and then side load Quinacridone Violet. Add dark pink tints to the darkest areas at the base of each petal.

7 Add Light Tints to Petals

Dress a no. 10 shader with extender and then side load Hansa Yellow + Napthol Red (2:1). Add yellow tints to the light areas of the petals on the right side of the flowers. Dress a no. 10 shader with extender and side load Sapphire Blue. Add blue tints along the left edges of the petals. Let the extender dry. Then seal the surface with glazing medium.

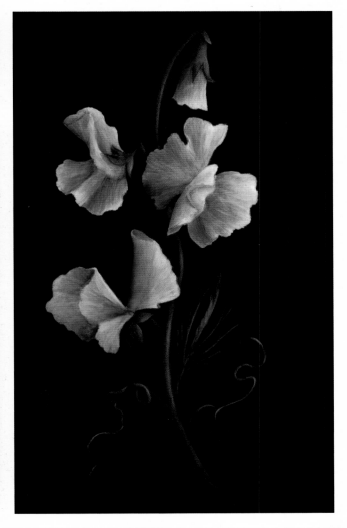

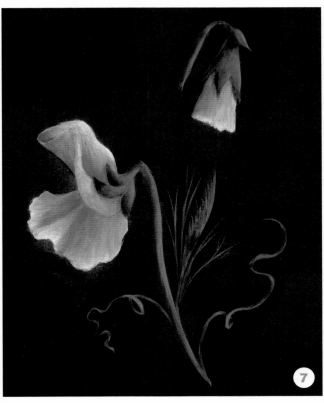

Tiger Lily 1

JANE MADAY

MEDIUM: *Watercolor*

COLORS: **Holbein:** *Cadmium Yellow Light • Opera • Olive Green • Hooker's Green*
Winsor & Newton: *Brown Madder*

BRUSHES: **Silver Brush Limited:** *Ultra Mini Designer Round, series 2431S - nos. 6 & 12*

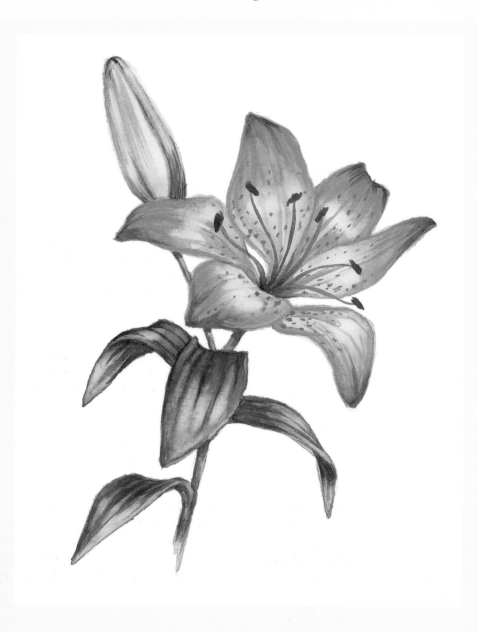

1

2

3

4

artist's comment

For this painting, you lift highlights out of the dry paint with clean water. This gives a more glowing effect than overpainting with white.

1 Base

Basecoat, using a no. 12 Ultra Mini round. For the petals, work wet-in-wet, using Cadmium Yellow Light at the bases and Opera + Cadmium Yellow Light (2:1) at the tips. Let each petal dry before painting the next. The leaves and stems are Olive Green, with Cadmium Yellow Light towards the ends and Opera + Cadmium Yellow Light (2:1) at the tips. Base the bud with Olive Green + Cadmium Yellow Light (1:1). Drop in some Opera while the bud is still wet.

2 Shade

Shade the petals with Brown Madder, dropping in a little Hooker's Green to the flower center. Shade the bud and stem with Brown Madder + Olive Green (1:1). Shade the leaves with Hooker's Green + Brown Madder (1:1).

3 Highlight

When the paint is dry, pull out highlights with a brush moistened with clean water. The brush should be damp, not sopping wet.

4 Detail

Switch to a no. 6 Ultra Mini round. Apply more Brown Madder to the petals. Also paint the speckles. Mix a tiny amount of Hooker's Green with Brown Madder for the stamens. For the anthers, use a darker leaf-shading mix (Hookers Green + Brown Madder [1:1], mixed with less water). Also use this mix to detail the leaves, the bud tip and the petal tips. Strengthen the Opera on the bud, if necessary.

Tiger Lily 2

LIAN QUAN ZHEN

MEDIUM: *Chinese watercolor*

COLORS: **Chinese painting colors or Sumi Colors:** *White • Yellow • Vermilion • Carmine • Rouge*

BRUSHES: **Chinese brushes:** *Small • Medium • Large*

OTHER SUPPLIES: *Raw Shuan paper (unsized rice paper), 14½" x 22" (37cm x 56cm) • Chinese painting ink or Sumi ink • Name chop (Chinese name stamp), optional*

R through Z

1 Paint a Petal

Load the large brush with Yellow, Vermilion, Carmine, and Rouge as explained in the "Loading the Brush" sidebar on this page. Holding the brush sideways, paint the first petal from the tip to the flower center.

2 Add Petals

Paint four more petals in the same way. Don't leave your brush on the paper very long, or the paint will overblend, and you'll lose your shapes. You don't need to clean the brush when you need more colors. Just dip the brush tip into water and tilt the brush upside down. Then load the colors again.

loading the brush

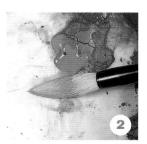
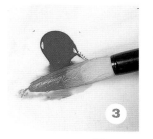
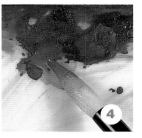
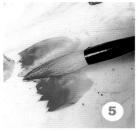

Loading several colors in a brush is common in Chinese painting. Here you see the loading of four colors.

1 Soak the brush in water and let the water drip from the tip until no more drops form. Then hold your brush sideways and use the heel to pick up the first color (Yellow). Just touch the color lightly and roll the brush to allow all sides of the heel to absorb the color.

2 Use the upper middle of the brush to pick up the second color (Vermilion).

3 Use the lower middle part of the brush to pick up the third color (Carmine).

4 Dip the brush tip into the fourth color (Rouge).

5 Touch the colors lightly and roll the brush as you did when loading the first color. The colors may not mix well on the brush; dabbing the brush on the palette lets the colors blend smoothly.

Tiger Lily 2

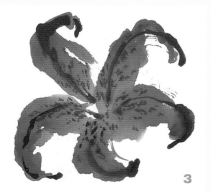

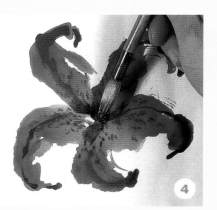

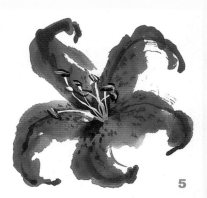

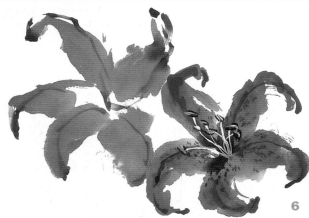

R through Z

3 Detail the Petals

Load the medium brush with Rouge on the tip and middle area. Mix a little ink on the brush tip. Paint the center strokes and spots on each petal while the previously applied colors are wet.

4 Paint Flower Center

To paint the flower center, soak the medium brush with Yellow. Add Carmine to the middle of the brush and dip the tip in a little ink. Hold the brush at a 60-degree angle from the paper, with the brush tip toward the flower center. Paint a few strokes.

5 Add Stamens

Now use the small brush to paint the stamens with very thick White. Each stamen is one stroke. Add a little Carmine to the stamen tips, and then outline the tips with ink.

6 Paint Second Flower

Paint the second flower as you did the first, only with lighter colors. Don't try to imitate the flower shape. Instead try to capture the feeling and essence.

7 Paint Sepals and Stems

After finishing the second flower, use the large brush to paint the sepals and stems. Load Vermilion at the middle and the heel and Carmine at the tip. Mix with a little ink. Paint the sepals before the stems.

8 Paint Buds and Their Sepals and Stems

Load the medium brush with Yellow at the heel, Vermilion in the middle, and Carmine at the tip. Hold the brush perpendicular to the paper to paint the buds. Immediately load with ink and outline two bud tips. Using the large brush, paint the sepals and stems as you did in step 7.

9 Paint Leaves

Clean the large brush and load it with Yellow at the heel, Vermilion in the middle and ink at the tip. Holding the brush sideways, paint a couple of fast strokes from the bottom of the leaf up. Broken strokes depict the texture of the leaves well.

10 Add Leaves and Paint Grasses

Paint more leaves with lighter ink. Paint grasses with the small brush and intense ink. To balance the composition, sign and stamp your name on the bottom left.

Tree Orchid

SHERRY NELSON

MEDIUM: *Oil*

COLORS: **Winsor & Newton Artists' Oil Colour:** *Ivory Black • Titanium White • Raw Sienna • Sap Green • Olive Green • Cadmium Yellow Pale • Purple Madder • Winsor Violet*

BRUSHES: **Winsor & Newton:** *Red Sable Bright, series 710 - nos. 2, 4 & 6 • Liner, series 740 - no. 0*

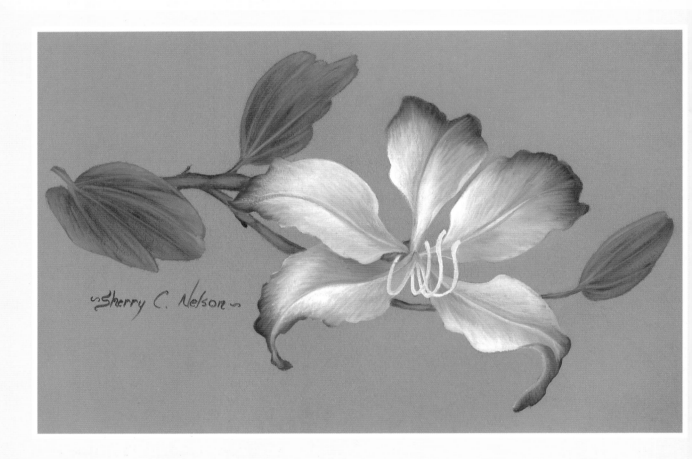

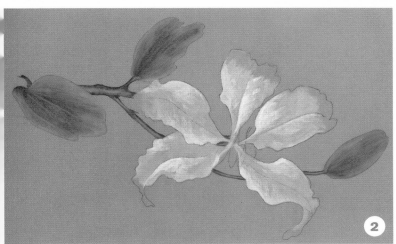

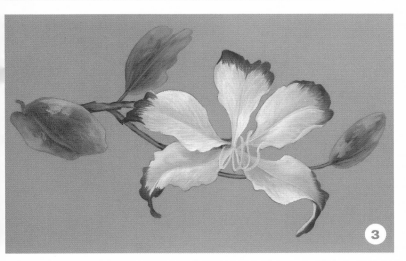

artist's comment

In this demonstration, a plus sign (+) indicates brush-mixed colors. These mixes vary naturally and create a more realistic look.

1 Base Petals and Leaves
Base all but the tips of each petal with Titanium White + Olive Green. Paint the dark areas of the leaves and stems Ivory Black + Sap Green + Olive Green. Paint the light areas Sap Green + Titanium White.

2 Highlight Petals, Blend Leaves
Place petal highlights with Titanium White. Blend on the leaves and stems where the values meet. Follow the growth direction of the leaf.

3 Continue Petals, Greens and Stamens
Blend on the petals where the values meet, following the growth direction of the petals. Fill in the petal tips with Purple Madder + Winsor Violet + Raw Sienna. Shade at the base of some petals with a little Raw Sienna. Highlight the stems and leaves with Sap Green + Titanium White, using more white than you did in the mix in step 1. Base the stamens in Raw Sienna + Titanium White.

4 Add Finishing Touches
(See completed painting on opposite page.) Blend on the petal where the dark values meet the white. Add petal veins with a bit of Titanium White, and, in some, with a little of the dark mix (Purple Madder + Winsor Violet + Raw Sienna). Blend to soften. Also blend the petal shading where the values meet.

Blend the leaf and stem highlights. Using Sap Green + Titanium White, add leaf veins

Add stippled tips to the stamens with Cadmium Yellow Pale + Titanium White.

Trumpet Creeper

LIAN QUAN ZHEN

MEDIUM: *Chinese Watercolor*

COLORS: **Chinese painting colors or Sumi colors:** *Yellow • Carmine • Rouge*

BRUSHES: **Chinese brushes:** *Small • Medium • Large*

OTHER SUPPLIES: *Raw Shuan paper (unsized rice paper), 17½" x 23" (44cm x 58cm) • Chinese painting ink or Sumi ink • Name chop (Chinese name stamp), optional*

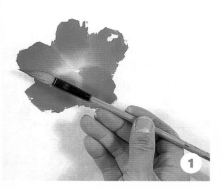
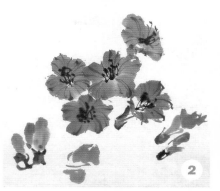
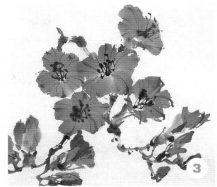

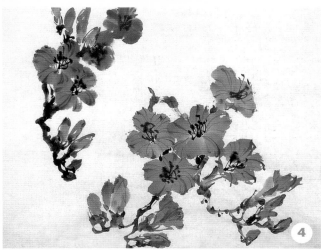

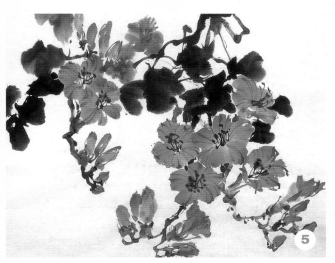

1 Paint Flower Petals

Load the medium brush with Yellow at the heel, Carmine at the middle and Rouge at the tip (See "Loading the Brush," page 107.) Hold the brush sideways with the tip pointing away from the flower center and paint the petals with one stroke each.

2 Paint Buds, Petal Veins, Stamens and Sepals

Paint the buds with the same brush and colors. Hold the brush sideways with the tip toward the upper part of the buds. Then mix Carmine and Rouge with a small brush and call out the petal veins.While the colors are about 60 percent dry, paint the stamens and sepals with ink.

3 Ink in the Stems

Wet the medium brush and dip the tip in ink. Dab the brush on your palette so the ink blends into the brush's middle. Holding the brush slightly sideways, paint the stems.

4 Add the Second Flower Group

Paint the second flower group as you painted the first. Paint the two flowers in the upper middle lightly and loosely to create depth.

5 Ink in Darker Leaves

Wet the large brush a little and load the tip and middle with ink. Holding the brush sideways, paint the darker leaves, using two or three strokes for one leaf.

6 Add Lighter Leaves, Add Veins

(See completed painting on previous page.) Add some lighter leaves for contrast and depth. While the leaves are wet, paint their veins with a medium brush, using light ink on the lighter leaves and dark ink on the darker leaves. Sign and stamp your name on the bottom left, which will balance the composition.

Wild Larkspur

ERIN O'TOOLE

MEDIUM: *Watercolor*

COLORS: **Winsor & Newton:** *Ultramarine • Burnt Sienna • Aureolin • Sap Green*
Holbein: *Opera*

BRUSH: **Isabey:** *Kolinsky sable - no. 6*

OTHER SUPPLIES: *Pencil • Kneaded eraser*

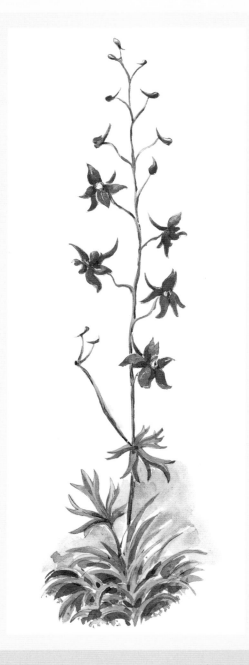

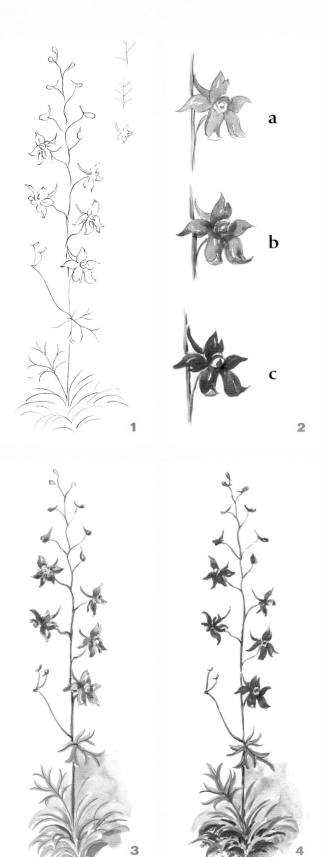

1 Make Pencil Sketch

Start with a pencil sketch, noting whether the flowers are attached to the stem alternately or opposite to each other. Also note the leaf and flower shapes. Larkspur is a five-petal flower with a spur out the back. Before you paint, lighten your pencil drawing with a kneaded eraser.

2 Paint the Flowers

a. Underpaint the flowers with Opera.
b. While the paint is still wet, float in some Ultramarine.
c. When the flowers are totally dry, overpaint lightly with more Ultramarine.

3 Begin Stem, Leaves, Soil and Background

Lightly define the stem and leaves with Aureolin and Sap Green. Use thin Burnt Sienna on the soil and thin Ultramarine for the background. (In this view, the blossoms have not yet been overpainted with Ultramarine.)

4 Add Dark Values

Deepen the shadow areas with Burnt Sienna and Ultramarine Blue. Darken the leaves, near their bases. Add Burnt Sienna and Ultramarine specks to the soil. Let dry completely, and then erase the pencil lines.

5 Apply Finishing Touches

(See completed painting on opposite page.) Finish up with tiny bits of Burnt Sienna in the darkest shadows of the flowers and along the sides of the stem. If the flowers are too blue, add a bit more Opera.

artist's comment

Take a field guide with you when you look for wildflowers to paint so you can learn more about flower habitats and history. I like to take two guides, one with drawings (Golden) and one with photographs (Audubon).

Wild Rose

JODIE BUSHMAN

MEDIUM: *Acrylic*

COLORS: **Delta Ceramcoat:** *Peony • White • Burnt Sienna • Straw • Crocus Yellow • Medium Foliage Green • Light Foliage Green • Berry Red • Maroon • Wild Rose*

BRUSHES: **Loew-Cornell:** *Angular shader, series 7400 - ¼-inch (6mm) • Liner, series 7350C - no. 0 • Filbert, series 4500 - no. 2*

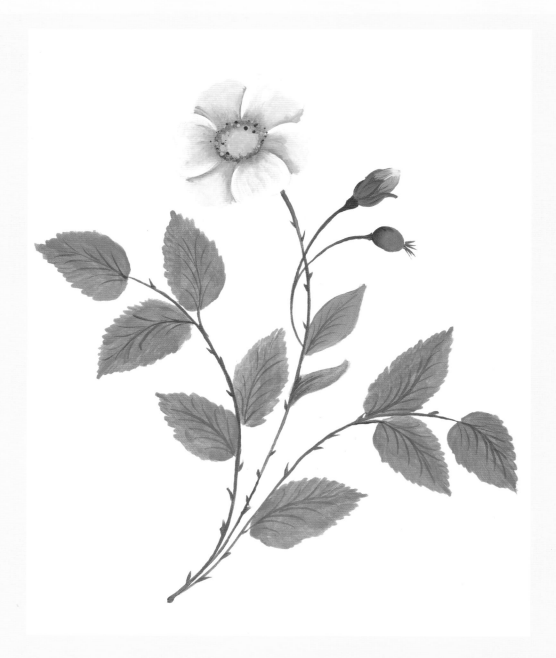

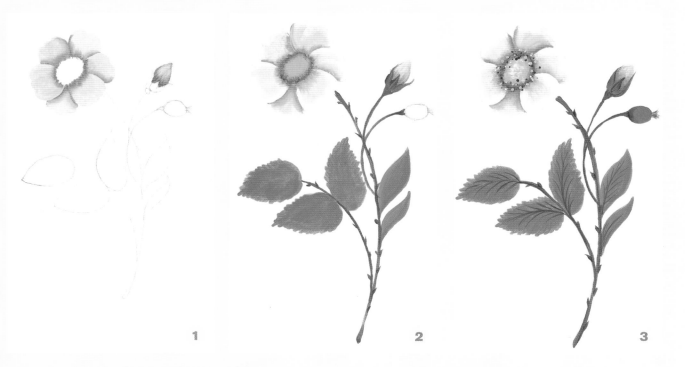

1 2 3

1 Base Petals and Bud, Shade Petals
Load a ¼-inch (6mm) angular with Peony and base the rose petals and bud. Side load Wild Rose to shade and separate the petals.

2 Begin Green Elements and Flower Center
With the angular and Light Foliage Green, fill in the leaves. Most of the leaves have jagged edges, but the two leaves connected to the center stem are smooth-edged and have a bit of Straw added to the green.
 Tap in the flower center with Crocus Yellow. Shade with Straw and a bit of Burnt Sienna. Highlight the petals with White. Paint the stems and "stickers" with a liner-brush mix of Burnt Sienna + Straw + Medium Foliage Green.

3 Apply Finishing Touches
Paint the leaf veins with thinned Medium Foliage Green and a no. 0 liner. Paint the rose hip Berry Red, shaded with Maroon. Paint the rose hip "whiskers" Burnt Sienna. Darken petal shading with Berry Red. Dot around the flower center with Burnt Sienna and with Crocus Yellow. Highlight the center with White.

artist's comment

These pretty little blooms grow on such a brambly, stickery bush, people leave them alone. Wildlife loves the protection this bush provides.

Round-Brush Flowers

LAURÉ PAILLEX

MEDIUM: *Acrylic*

BRUSHES: *Round • Liner • Filbert (used only on clover and thistle) - Choose brush sizes appropriate for size of flowers you wish to paint.*

artist's stroke worksheet

You can create a variety of flowers using just one type of brush. These two pages show round-brush flowers. For best results, first practice the strokes.

Comma Stroke
Apply pressure, pull and lift as the stroke comes to a point.

Liner-Brush Petal Stroke
A liner brush is considered a round brush. Liner brush-strokes are ideal for long, narrow petals.

Short Strokes
Generously load the tip of a small round or spotter. Strokes may form short, straight commas or be flipped to the side for small, heavily textured petals.

Fine-Line Petal Strokes
Pull these liner brushstrokes from the flower center outward.

CLOVER

1 Place All Elements
Establish flower head with light pink and green. Place short petals around the edges with double-loaded pink and white. Start at the stem and work upward. Place stems with a liner. Double load a filbert with two greens and paint each leaf with three short strokes.

2 Fill Flower, Shade and Detail
Fill the flower with short strokes. Let dry. Float shadows along the bottom edge. With a liner, add center leaf veins and place detail strokes where the stems join the flowers.

3 Highlight and Detail
Highlight the petals with heavy white strokes. Detail leaves with white overstrokes.

ASTER

1 Base

Pull liner-brush petals inward toward flower center. Use a variety of blue, blue-violet and red-violet hues. Add stems with liner brushstrokes. Add a calyx to side-view blossoms by touching the liner tip to the surface and pulling sideways with a short flip or two, joining the stem to the petals.

2 Highlight

Add highlighted petals by mixing white to the base colors.

3 Tap in Center

Tap soft yellow and green in the centers and finish with white pollen dots.

DAISY

1 Place
Petals, Stems and Leaves

Load your brush with pale green, tip with white, and paint comma-stroke petals. Reload the brush often for consistency. Place the stems with a liner. Double load with two values of green and add leaves with a variety of round or liner brush-strokes.

2 Shade Around Centers

Float shading around the flower centers.

3 Highlight Petals, Paint Centers

Highlight selected petal tips. Place flower centers with yellow and golden brown. Add tiny pollen dots.

THISTLE

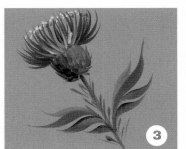

1 Place
Elements

Place stem and blossom base with green values. Pull fine-line petals with purple and red violet hues.

2 Fill Out Head

Fill out the flower head with more fine-line strokes. Over-stroke the base with short round strokes.

3 Add Finishing Details

Highlight petals with light values and add white pollen dots. Shade and detail the base and stem. For leaves with a variety of thin-thick-thin strokes, use a round or liner brush loaded with light and dark green hues

Filbert-Brush Flowers

Lauré Paillex

MEDIUM: *Acrylic*

BRUSHES: *Filbert • Liner - Choose brush sizes appropriate for size of flowers you wish to paint.*

artist's stroke worksheet

You can create a variety of flowers using primarily one type of brush. These two pages show filbert-brush flowers. For best results, first practice the strokes.

Comma Stroke
Pull brush in a curve from its flat edge onto its knife edge.

Tipped Stroke
Load brush. Then touch the tips of the hairs into another color. Press to spread and flatten bristles and then pull and lift to create a short rounded petal streaked with color.

Heart Strokes
Place two side-by-side strokes, turning the brush slightly toward the outside of the petal or leaf. Let the rounded brush tip form a notch where the strokes meet.

Multi Stroke
Double load or tip the brush. Press down to spread and flatten the bristles as you pull a petal inward toward the flower center. Connect strokes to complete each petal.

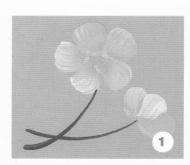

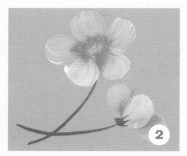

BUTTERCUP

1 Place
Petals and Stems
Place petals with yellow strokes tipped with white. Add stems with a liner.

2 Add Shading and Calyx
Float shading around the center and separate petals with antique gold hue. Add calyx to side-view blossom by touch-ing the liner tip to the surface and pulling sideways with a short flip or two, joining the stem to the petals.

3 Tap in Center
Tap in the flower center with orange and green. Add white pollen dots.

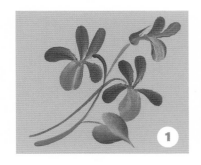
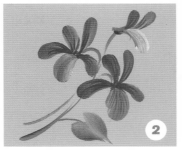
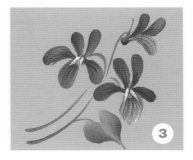

VIOLET

1 Base
Place back two petals with purple comma strokes. Add lighter-value side petals. For lower petal, place two side-by-side strokes in an even lighter value. Add stamens with a liner. Add a calyx as in step 2 of the buttercup (page 120). Double load a filbert with two greens for heart-stroke leaves.

2 Add Veins
Pull fine-line petal veins from the flower center outward.

3 Detail Stamens
Add stamen details.

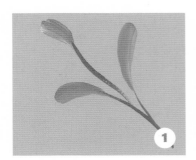
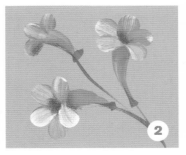
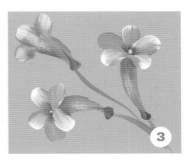

PHLOX

1 Paint
Trumpets and Stems
Form the trumpet with a long comma stroke in toward the stem. Tie in the stems with liner brushstrokes.

2 Add Petals, Shading and Calyxes
Add short, tipped petals that meet at the trumpet's top. Create the deep flower center with a floated shadow. Place calyxes at the base of each trumpet as explained in step 2 of the buttercup (page 120).

3 Add Stamens and Highlights
On each front-facing flower, add a tiny yellow dot to indicate a stamen. Drybrush white highlights to add softness and variety to the flower cluster.

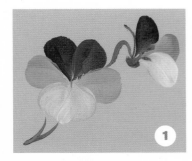
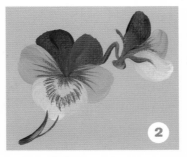
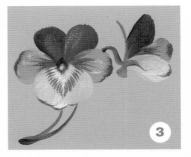

PANSY

1 Paint
Trumpets, Stems and Calyx
Place back petals, then side petals and then front petals, using tipped strokes. Indicate stems with liner brushstrokes. Paint the stems and calyx, noting how the stem approaches to the side-view flower with drooping crook. The calyx joins the petals to the stem at the bottom of the crook.

2 Add Shading and "Face"
Add the shading and "face" detail, using the knife edge of the brush.

3 Add Flower Details
Drybrush white highlights. Touch purple tints on the yellow petals. Add stamen detail.

Foliage-Brush Flowers

LAURÉ PAILLEX

MEDIUM: *Acrylic*

BRUSHES: *Angular bristle foliage · Liner · Round (options) Choose brush sizes appropriate for size of flowers you wish to paint.*

artist's stippling worksheet

You can create a variety of flowers using primarily one type of brush. These two pages show foliage-brush flowers. For best results, first practice the stippling techniques below.

Arched Shape
Double load a foliage brush with the dark value on the short bristles and the light value on the long bristles. Begin at the center of the flower with the light value facing upward. Then form an arch by lightly pouncing the brush to the left and to the right.

Spiked Effect
Double load a foliage brush with the dark value on the short bristles and the light value on the long bristles. Beginning at the flower base, pounce the knife edge of the brush along the stem toward the flower's tip.

Highlighting
Dip only the tips of the long bristles into paint. Tap lightly onto the areas of the flower to be highlighted.

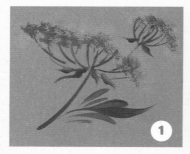

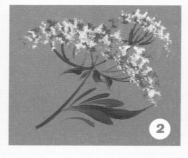

QUEEN ANNE'S LACE

1 Place Green Elements and Base Bloom
Place stems, framework and leaves with a liner brush loaded with two green values. Stipple an arched base using light- and medium-value green hues.

2 Highlight
Stipple white highlights.

3 Add Petals
Add tiny white detail petals, using a tipped foliage brush or a small round brush.

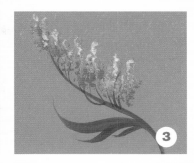

GOLDENROD

1 Place Green Elements

Place the stems and framework with a liner. Stroke the leaves with either a liner or a round brush that is loaded with two green values.

2 Add Spikes

Stipple spikes with the knife edge of a double-loaded foliage brush, using medium and dark yellow hues.

3 Highlight

Highlight the spike tips with light yellow and white.

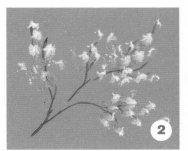
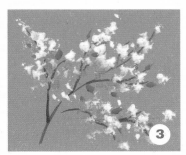

BABY'S BREATH

1 Place Green Elements

Place fine stems and framework with a liner.

2 Pounce Flowers

Pounce flowers with pink and off-white hues.

3 Highlight

Place highlights with the long bristles of the foliage brush tipped with white.

HEATHER

1 Place Green Elements

Place stems, framework and tiny leaves with a liner brush.

2 Stipple Spikes

Stipple spikes on stems using purple and lavender hues.

3 Highlight

Stipple random highlights with lightest lavender and white.

About the Artists

JODIE BUSHMAN teaches painting across the United States as well as in her own Rainshadow Studio in Oregon. She has been an Associate Designer for Delta Paint, is frequently published in popular painting magazines, and is the author of *The Big Book of Decorative Borders* and *450 Decorative Borders You Can Paint*, both North Light Books titles.

BETTY CARR, MFA, teaches painting workshops worldwide. In addition to writing *Seeing the Light: An Artist's Guide*, published by North Light Books, her work has been featured in publications such as *The Artist's Magazine, Southwest Art* and *International Artist*. She has won several prestigious awards, including a lifetime membership in the exclusive Knickerbocker Artists Society of New York City.

CAROL COOPER is an award-winning artist and a creative master teacher with two art degrees. She is the author of *No Experience Required! Watercolor*, published by North Light Books. In addition to college teaching, Carol conducts watercolor workshops internationally. Her Web site is http://faculty.nwacc.edu/ccooper.

DONNA DEWBERRY is known for her One Stroke painting method, which she has been teaching since 1995. In addition to appearances at seminars and conventions, Donna hosts the popular PBS series, *One Stroke Painting*. Spring Industries licenses her designs for wallpaper, fabrics, linens and other home décor items. Her prolific writing includes many titles published by North Light Books, including *Flowers A to Z with Donna Dewberry* and *Donna Dewberry's All New Book of One-Stroke Painting*.

BONNIE FREDERICO always loved art, but started her professional career as a math teacher. Her ability to teach led her into the decorative art field. In 1994, she became a Certified Decorative Artist. Bonnie teaches at home and at United States and Canadian conventions. She's been published in several painting magazines and authored North Light Books title, *Fresh and Easy Watercolors for Beginners*.

ARLENE SWIATEK GILLEN has been painting since 1995. She's a frequent contributor to the decorative painting magazines, author of *Classy Glass* and a travel teacher. Her floral designs grace walls, furniture, floorcloths, glassware and other home accessories. She welcomes questions and comments at Arlene.Gillen@adelpia.net

SHARON HAMILTON has a photography degree and is a Master Decorative Artist. She's been published in numerous magazines and has authored several painting books, including *Lush and Lively Flowers You Can Paint*, published by North Light Books.

LOUISE JACKSON, Master Decorative Artist, is an international painting instructor. She was the host of the television series, *Painting with Louise*, and her work is displayed in private, public and corporate collections, including the Smithsonian Museum's Christmas collection. Louise has authored many painting books, including North Light Books title, *Painting Flowers in Watercolor with Louise Jackson*.

LINDA KEMP, CSPWC, OSA, SCA, teaches an innovative approach to painting throughout Canada, the United States and the United Kingdom. her internationally recognized negative painting concepts are the focus of her book and video, *Watercolor: Painting Outside the Lines* (North Light Books). For more of Linda's work, see www.lindakemp.com.

SANDY KINNAMON, OWS, has been painting watercolors for 25 years. She has a BA in art and an AS in architecture drawing, and is the author of two watercolor books. She has exhibited her work at the American Watercolor Society exhibition and loves travel teaching and helping students. Sandy can be reached at her Web site, www.sandykinnamon.com.

GAYLE LAIBLE, Certified Decorative Artist, was art director for WLW-TV/Radio, serving Cincinnati, Dayton and Columbus, Ohio, for 13 years. For 24 years she owned The Nearsighted Owl, an art store, studio, framing shop and gallery. Gayle and her cousin, Sharon Saylor, own Sharon & Gayle Publications, Inc., publishers of how-to-paint books.

JANE MADAY has been a professional illustrator since she was 14. At 16 she became a scientific illustrator for the University of Florida. She worked 8 years as a greeting card artist for Hallmark Cards. In addition to writing art instruction books and articles, Jane licenses her work for products such as greeting cards, puzzles, stitchery kits and T-shirts.

MAUREEN MCNAUGHTON, Certified Decorative Artist, has been teaching internationally since 1980. She's known for her ability to make complex techniques understandable. As an appointee to the Society of Decorative Painters Task Force on Excellence in Teaching, she helped develop the Teacher Development Program. Her publications include videos, countless magazine articles and the North Light Books title, *Beautiful Brushstrokes Step by Step*.

SHERRY NELSON, Master of Decorative Arts, teaches in seminars and conventions worldwide. Her love and respect for the natural world is evident in her extensive field study, resulting in beautifully accurate and detailed depictions of its flora and fauna. Sherry has produced over 20 publications to date, including her North Light Books title, *Painting Flowers A to Z with Sherry C. Nelson MDA*.

ERIN O'TOOLE has filled journals with images of birds and flowers for over 25 years and is the author of North Light Books title, *Create Your Own Artist's Journal*. Erin's watercolors appear in many Sunset and Audubon books, including over 500 botanicals for the Western and National Garden books.

LAURÉ PAILLEX has been teaching decorative painting for over 25 years. She's authored numerous books, pattern packets and videos, and contributes regularly to decorative painting publications. Lauré also exhibits and teaches internationally, including in her home studio, Cranberry Painter Decorative Arts, in Cape Cod, Massachusetts.

MARGARET ROSEMAN is the founder, director and signature member of the Toronto Watercolour Society and has gained signature memberships in the Canadian Society of Painters in Watercolour and the Society of Canadian Artists. She is a recipient of the Commemorative Medal for the 125th Anniversary of Canadian Confederation. Margaret conducts watercolor workshops internationally. Her work has been featured in many art publications and may be found in corporate, public and private collections worldwide. Her Web site is www.margaretroseman.com.

BRIGITTE SCHREYER is an elected member of the Canadian Society of Painters in Watercolour, the Ontario Society of Artists and the Society of Canadian Artists. Besides appearing in exhibitions, her work is seen in corporate and private collections throughout North America and Europe. She gives watercolor instruction throughout Canada, with emphasis on light-and-shadow values and glazing techniques. Brigitte has contributed to several North Light Books titles. Her Web site address is www3.sympatico.ca/studio.b.

PENNY SOTO has won over 250 awards and has exhibited widely, including at the San Francisco World Trade Center, the Triton Museum and the Pacific Bell Corporation. She has 26 mural-size paintings in the United States' Nordstrom collection. She writes for many art magazines and authored North Light Books title, *Paint Glowing Colors in Watercolor*.

SUSANNA SPANN MFA and MA, exhibits in 20 to 25 art festivals a year and teaches across the country. She has received more than 500 awards and has earned signature memberships in the Florida Watercolor Society, the American Watercolor Society and the National Watercolor Society. Her work appears in magazines, is featured in many North Light Books titles and hangs in corporate collections, including City of Miami and Disney World.

MARY B. SPIRES is an international watercolor teacher and has taught at the Society of Decorative Painters' national and regional conventions for 12 years. For more information about Mary, plus her current artwork and teaching schedule, visit www.maryspires.com.

DIANE TRIERWEILER started painting 25 years ago and soon developed a desire to share her interest with others. Nineteen years ago, she and her husband opened The Tole Bridge, an art shop and teaching facility. Diane also teaches all over the United States. She has published seven books, about 150 pattern packets and videos. She also has a specialty brush line.

KERRY TROUT is a self-taught artist who has been painting since childhood. She's the author of four North Light books, her most recent being *Handpainted Gifts for All Occasions*. Kerry also sells her projects on CD-ROM. Kerry developed Liquid Shadow, a water-based medium that enables painters to easily paint cast shadows and deepen shading.

PAT WEAVER is an international watercolor instructor who has received numerous awards for her work from watercolor societies, universities, businesses and more. She also has extensive publication credits including features in *American Artist*, *Watercolor Magic* and the book, *Splash 7*. She is the author of North Light Books title, *Watercolor Simplified*.

MARK WILLENBRINK is a fine artist, author/illustrator and watercolor teacher. He is a contributing editor for *Watercolor Magic* magazine and is the author of *Watercolor for the Absolute Beginner*, published by North Light Books. For more information, visit www.shadowblaze.com

LIAN QUAN ZHEN teaches Chinese and watercolor painting workshops internationally. His paintings hang in numerous institutional and private collections, including the MIT Museum, which has collected 14 of his paintings. He has published two titles with North Light Books: *Chinese Painting Techniques for Exquisite Watercolors* and *Chinese Watercolor Techniques: Painting Animals*.

Resources

Cheap Joes Art Stuff
374 Industrial Park Drive
Boone, NC 28607
800.227.2788
www.cheapjoes.com

Chinese Watercolor Supplies
(See Zhen Studio)

ColArt Americas
11 Constitution Avenue
Piscataway, NJ 08855-1396
732.562.0770

Daler-Rowney USA Ltd.
2 Corporate Drive
Cranbury, NJ 08512-9584
609.655.5252
www.daler-rowney.com

Daniel Smith
P.O. Box 84268
Seattle, WA 98124-5568
800.426.7923
www.danielsmith.com

DaVinci Paint Company
11 Good Year Street
Irvine, CA 92618
800.553.8755
www.davincipaints.com

DecoArt
P.O. Box 386
Stanford, KY 40484
606.365.3193
www.decoart.com

Delta Technical Coatings, Inc.
2550 Pellissier Place
Whittier, CA 90601
800.423.4135
www.deltacrafts.com

Diane Trierweiler's Signature Brushes
(See The Tole Bridge)

Dick Blick Art Materials
P.O. Box 1267
Galesburg, IL 61402-1267
800.723.2787
www.dickblick.com

Dr. Ph. Martin's
(See Salis International Inc.)

Dynasty
70-02 72nd Place
Glendale, NY 11385
718.821.5939
www.dynasty-brush.com

Grumbacher
(See Sanford)

Holbein
e-info@Holbein-works.co.jp
www.holbein-works.co.jp/english/

Isabey
(See Cheap Joe's Art Stuff and Dick Blick Art Materials)

Loew-Cornell
563 Chestnut Avenue
Teaneck, NJ 07666-2490
201.836.7070
www.loew-cornell.com

MaimeriBlu
(See Cheap Joe's Art Stuff and Dick Blick Art Materials)

Maureen McNaughton Enterprises Inc.
RR #2
Belwood, ON, N0B 1J0
Canada
519.843.5648
www.maureenmcnaughton.com

Plaid Enterprises, Inc. (FolkArt)
P.O. Box 7600
Norcross, GA 30091-7600
678.291.8100
www.plaidonline.com

Princeton Art and Brush Company
(See Cheap Joe's Art Stuff and Dick Blick Art Materials)

Robert Simmons Brushes
(See Daler-Rowney USA Ltd.)

Royal Brush Manufacturing
(Royal & Langnickel)
6707 Broadway
Merrillville, IN 46410
800-247-2211
www.royalbrush.com

Salis International Inc.
301 Commercial Road
Suite H
Golden, Colorado 80401
800.843.8293
www.docmartins.com

Sanford
800.323.0749
www.grumbacherart.com

Sennelier
Max Sauer S.A.
2 rue Lamarck
BP 204 - 22002

St-Brieuc Cedex France
+33 02 96 68 20 00
www.sennelier.fr/

Silver Brush Limited
P.O. Box 414
Windsor, NJ 08561-0414
609.443.4900
www.silverbrush.com

Sumi painting materials
(See Cheap Joe's Art Stuff and Dick Blick Art Materials)

The Tole Bridge
1875 Norco Drive
Norco, California.
95.272.6918
www.dianetrierweiler.com

Winsor & Newton
(See ColArt Americas)

Zhen Studio
P.O. Box 33142
Reno, NV 89523
lianzhen@yahoo.com
(Send a letter or an e-mail with your inquiry.)

Index

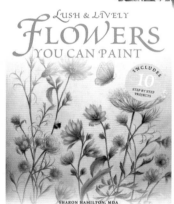
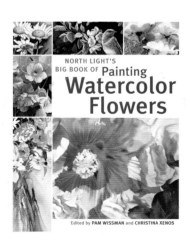